UNDERWATER
PUPPIES

Also by Seth Casteel

Underwater Dogs

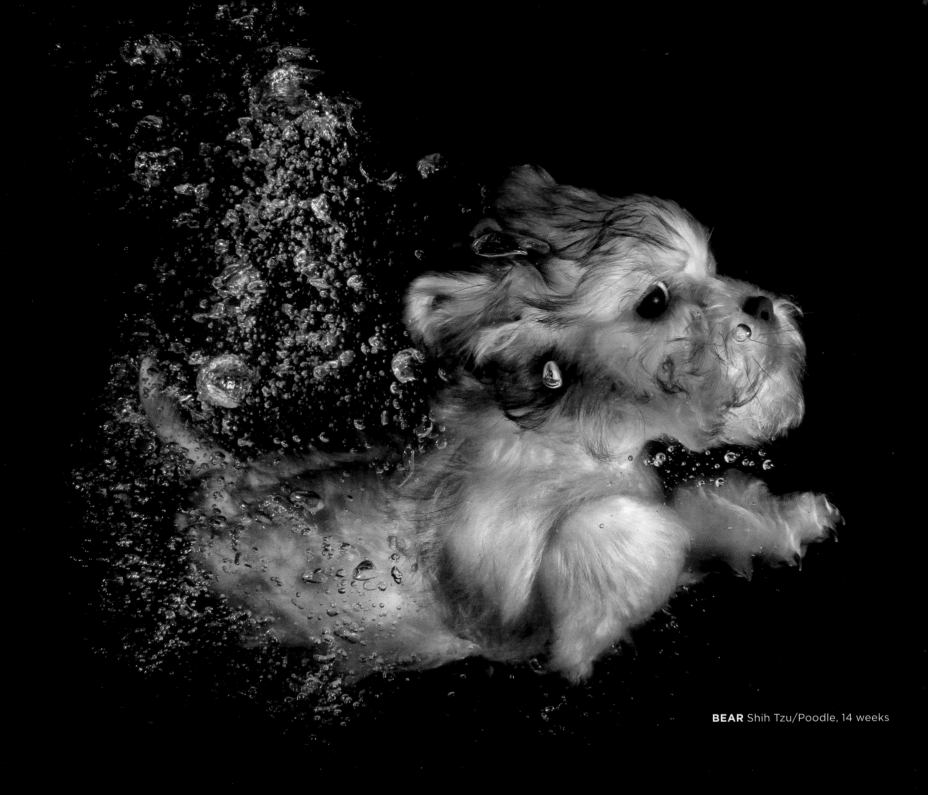

BEAR Shih Tzu/Poodle, 14 weeks

POPSICLE Puggle Mix, 9 weeks

UNDERWATER PUPPIES

Seth Casteel

LITTLE, BROWN AND COMPANY
New York Boston London

Little, Brown and Company
Hachette Book Group
237 Park Avenue, New York, NY 10017
littlebrown.com

First Edition: September 2014

Little, Brown and Company is a division of Hachette Book Group, Inc. The Little, Brown name and logo are trademarks of Hachette Book Group, Inc.

The publisher is not responsible for websites (or their content) that are not owned by the publisher.

The Hachette Speakers Bureau provides a wide range of authors for speaking events. To find out more, go to hachettespeakersbureau.com or call (866) 376-6591.

The on-land photos of the puppies are a collaborative effort from Seth Casteel and the puppies' parents.

ISBN 978-0-316-25489-2 (hc) / 978-0-316-29729-5 (Scholastic edition)
Library of Congress Control Number 2014937388

10 9 8 7 6 5 4 3 2 1

SC

Design by Gary Tooth/Empire Design Studio

Printed in China

I dedicate this book to puppies everywhere. Thank you for sharing your love and bringing smiles to our faces.

CONTENTS

x Introduction

1 Underwater Puppies

112 The Puppies on Land

115 Acknowledgments

116 About Seth Casteel

INTRODUCTION

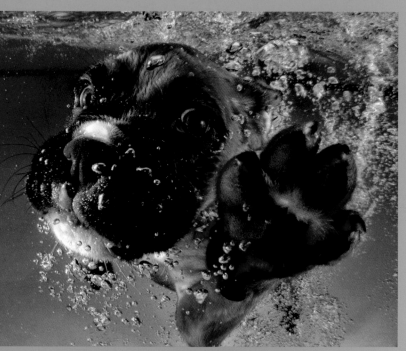

Puppies inspire an overwhelmingly positive reaction in so many of us. We are drawn to puppies because of their appearance and are captivated by their personalities as we watch them explore the world. It's exhilarating because, unlike human babies, puppies become adults in just a few short months. Since they develop so quickly, it's especially important to savor our time with them and to ensure that, during this window, we as puppy parents are doing the right things to prepare them to be part of our world.

If you decide you would like a puppy in your life, then you have to be ready to prime that puppy for a variety of places and situations. The more we can expose our puppies to the world when they are young, the more we will see their experiences reflected in their confidence and happiness as adults.

Puppies Know How to Swim???

Puppies already know how to swim even at just a few weeks old. Some are more successful than others, but they all need practice to better understand their physicality, which improves their overall swimming ability. Swimming may be innate, but dogs didn't evolve with the luxury of swimming pools; since a swimming pool is not a natural body of water, there are different rules that apply. Natural bodies of water such as lakes, rivers, and oceans generally have a gradient, providing a simple way of exiting. Swimming pools usually have one exit, which is often a set of steps. If the puppy doesn't know where those stairs are, he is going to have trouble, so the most important thing to teach our puppies is how to get out of the pool on their own.

I think people make a mistake with their puppies and swimming when they assume their puppy can't swim and that the water is dangerous. In actuality, what these owners are doing is creating a hazardous scenario for the puppy by denying him his right to practice, especially in a swimming-pool situation.

When puppies reach a certain age, they become so curious that

they are fearless. During this time, it's important to develop these curiosities into confidence.

That's of course when it gets especially interesting for me. Seeing tiny puppies jump in on their own and swim to the ramp—it's incredible to watch them do it! In this book, among a range of underwater puppy experiences, you will see photographs of twelve-week-old Yellow Labrador Retrievers voluntarily diving to the bottom of a four-foot swimming pool to retrieve toys!

Rescue Puppies
It was important to me to feature dozens of adoptable and adopted puppies in this book to remind people that adoption is a fantastic option when considering bringing a puppy into your life. With a little research, you can find the type of rescue puppy you are looking for, pay a fraction of the price you would to a breeder, and save a life—a win-win-win! I want to thank all of the wonderful animal rescue organizations that made this book possible. Your tireless efforts to make the world a better place for animals is inspiring!

Do You Really Want a Puppy?
As much as we all love puppies, we aren't all necessarily in the ideal situation to care for one. So many people underestimate the responsibility involved. Before making your decision, you should also consider adopting a senior pet. These little friends have lived and learned and are generally going to be much easier to integrate into your home. And they won't chew up your brand-new shoes or destroy the carpet, either!

Puppies in This Book
I met a first-grade teacher in Chicago and spoke with her about *Underwater Puppies*. She told me that one of the reasons she is a first-grade teacher is that she has the privilege of witnessing important moments in her students' lives. She asked me, "How do you feel with the puppies?"

I said, "I feel like a first-grade teacher!" I experience so much pride when watching puppies swim for the first time. They've learned something they'll benefit from for the rest of their lives.

The puppies in the following photographs were ages six weeks to six months when I swam with them. Each puppy received swimming lessons to help prepare him to be part of the book and the world. I photographed more than a thousand puppies throughout the United States to achieve this collection of photographs.

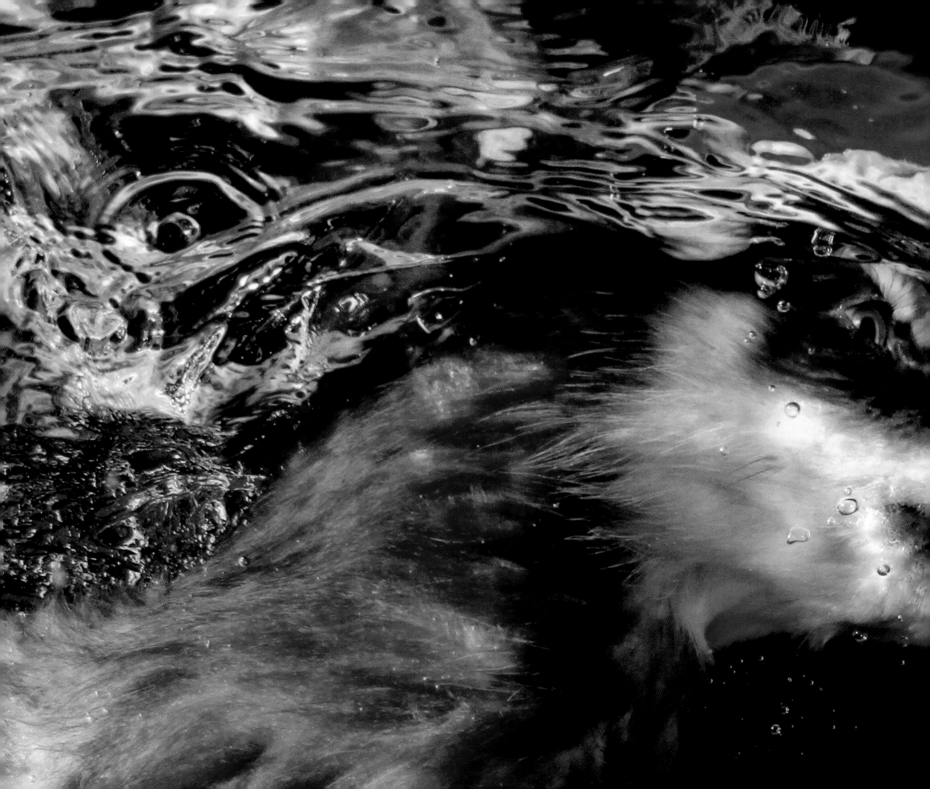

UNDERWATER
PUPPIES

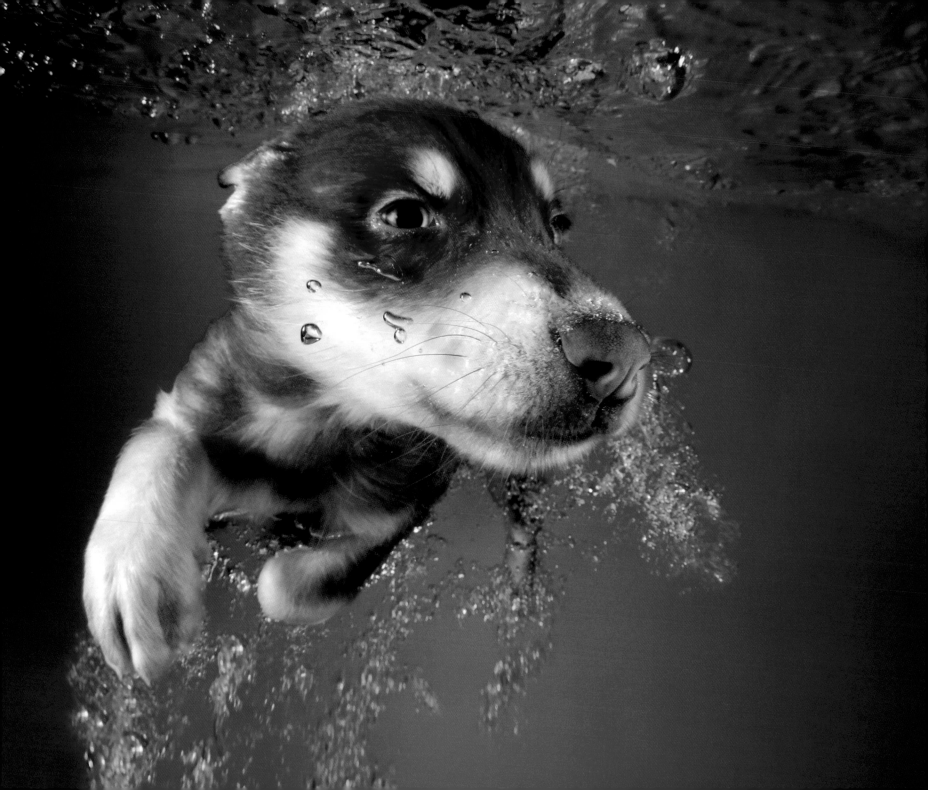

MARLOWE Vizsla, 10 weeks

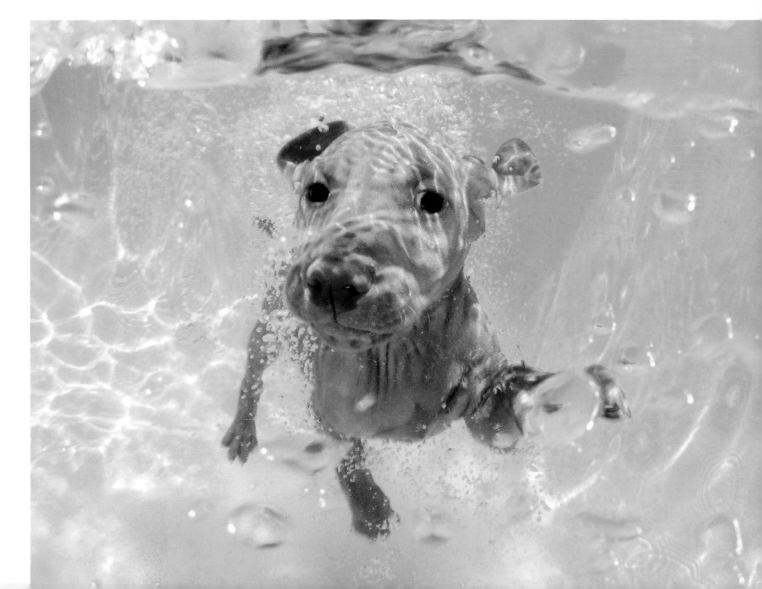

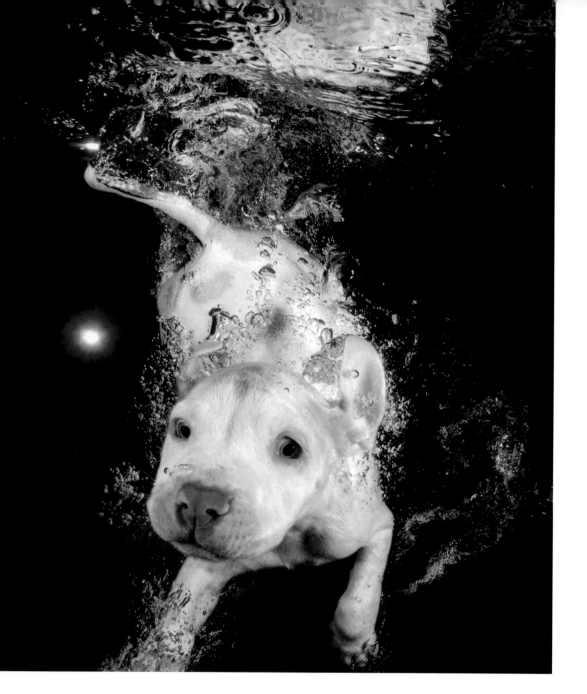

PRINCE Boxer, 8 weeks

BLANCO American Pit Bull Terrier, 7 weeks

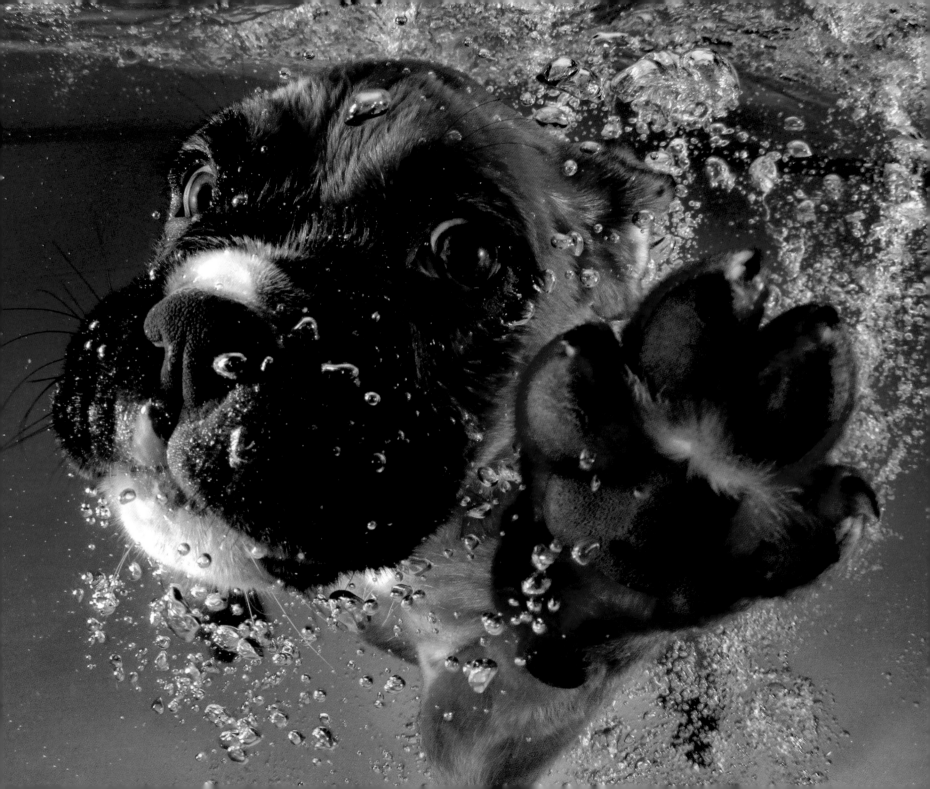

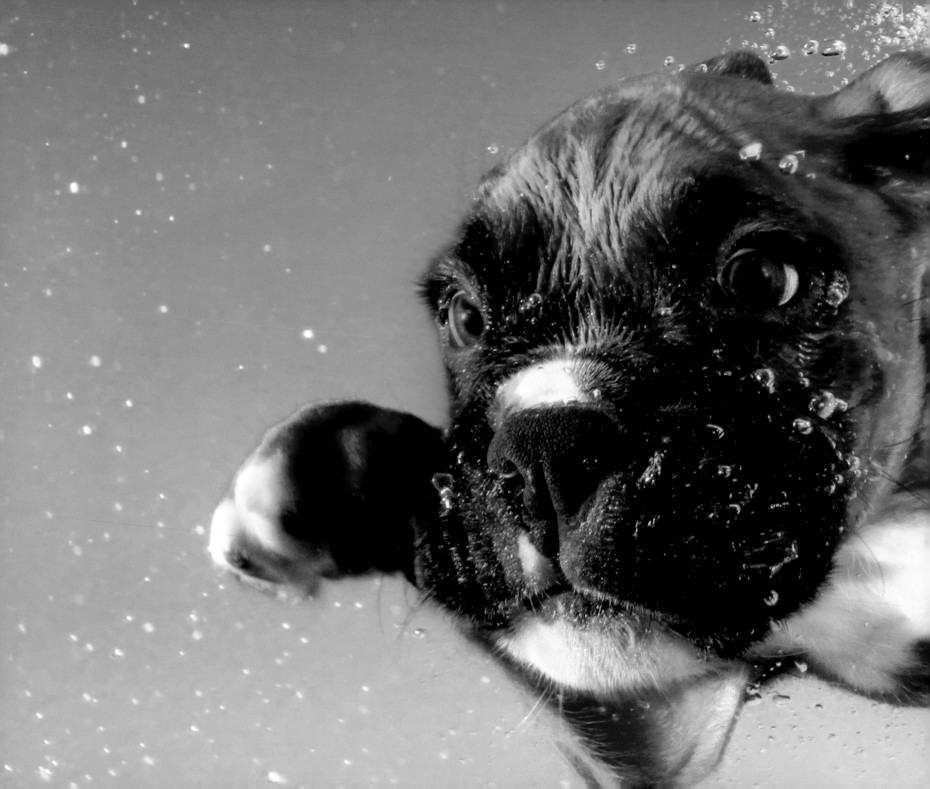

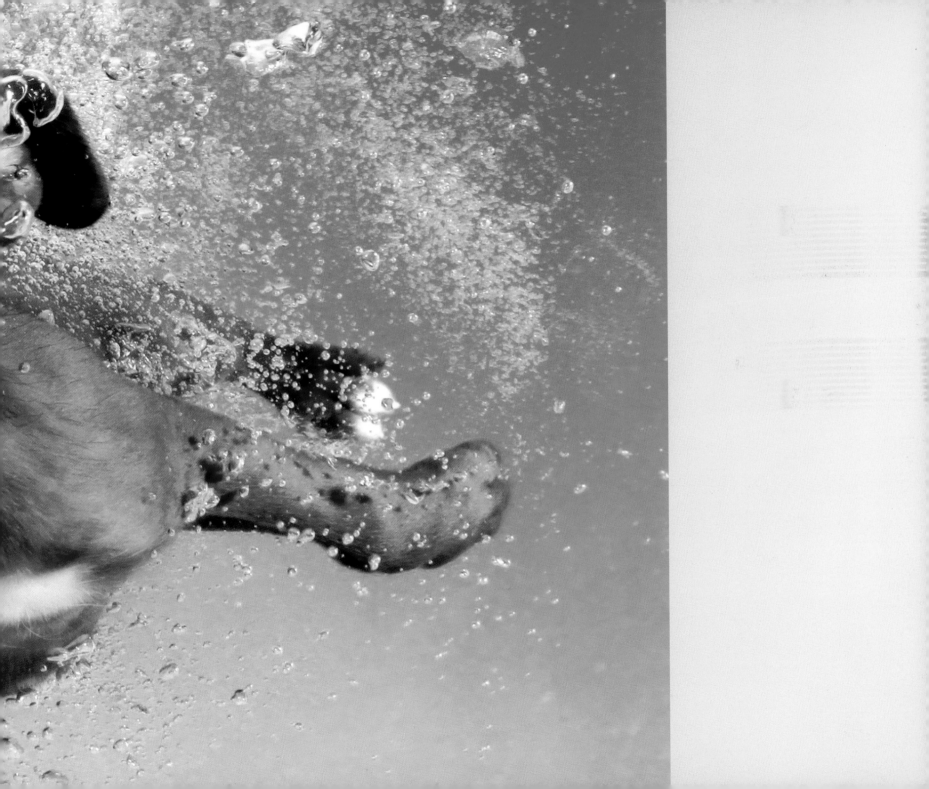

PANSY American Pit Bull Terrier, 7 weeks

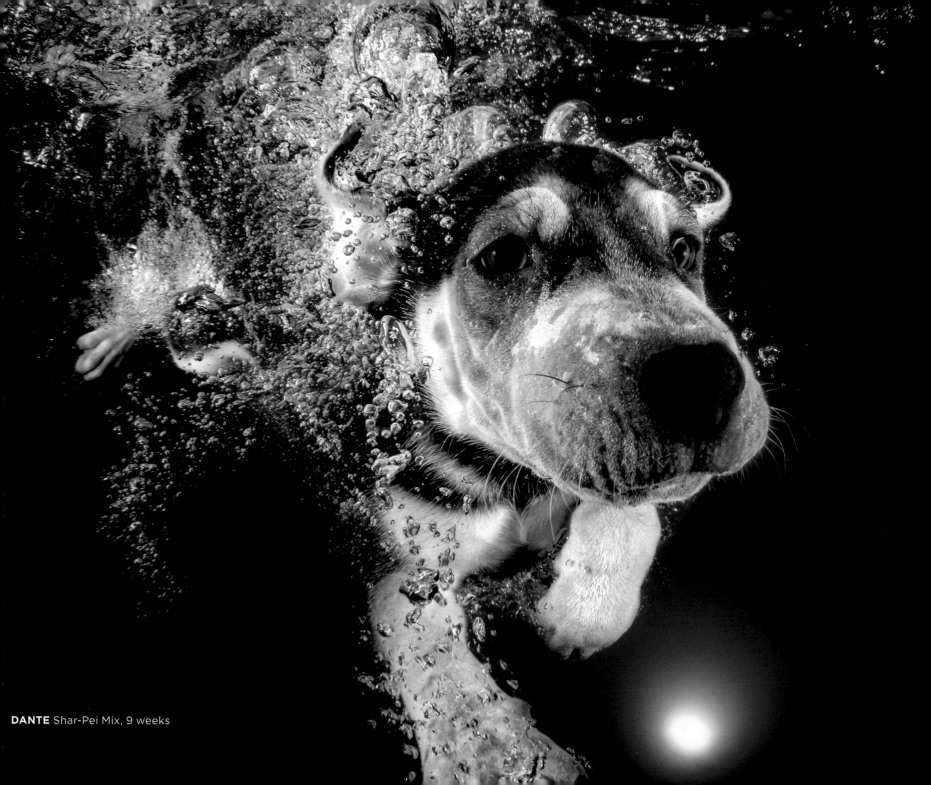

DANTE Shar-Pei Mix, 9 weeks

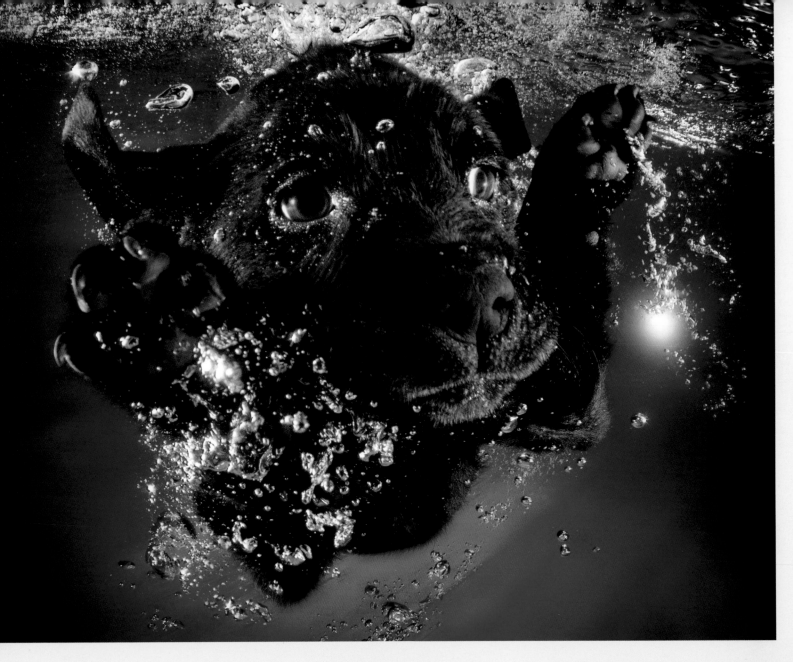

RUGER Black Labrador Retriever, 7 weeks

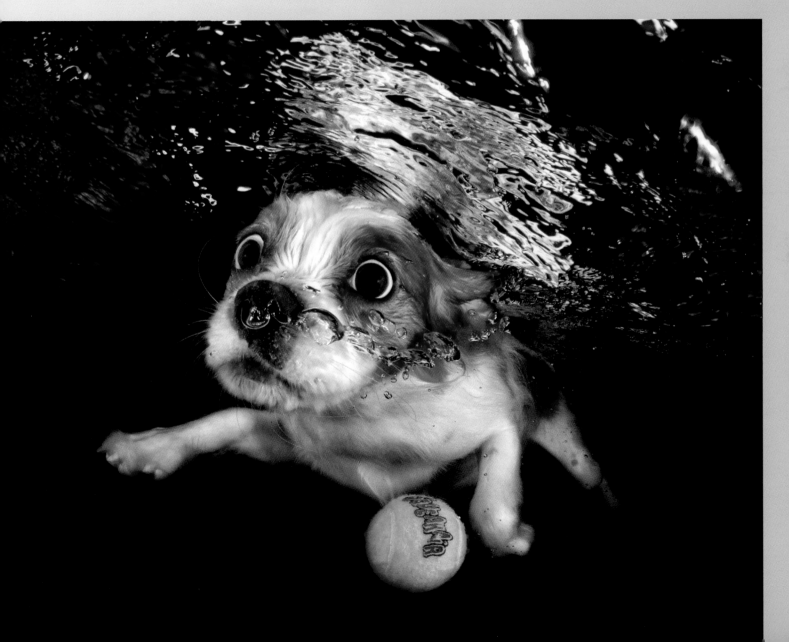

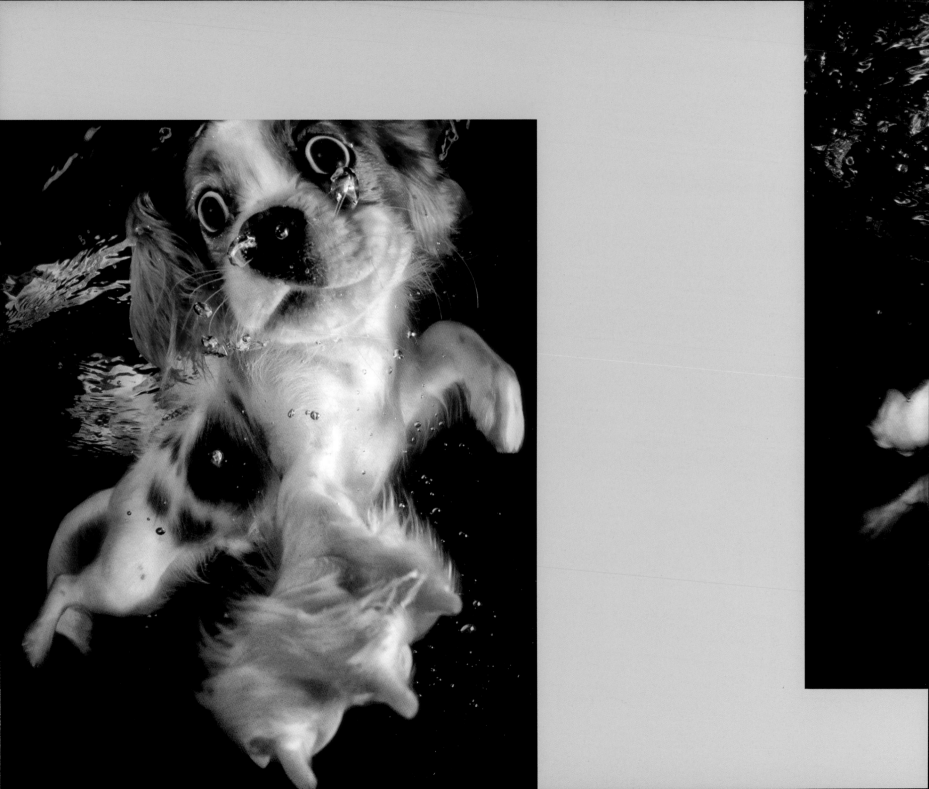

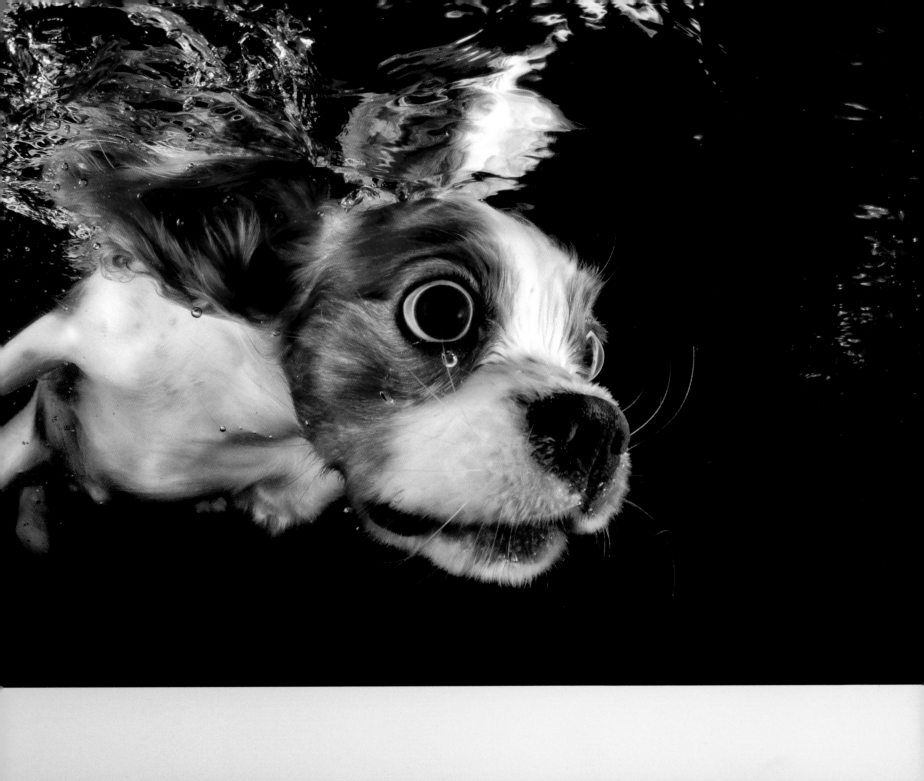

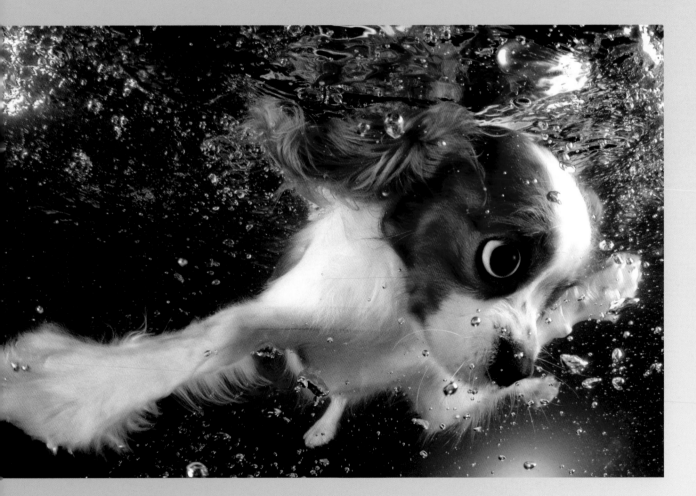

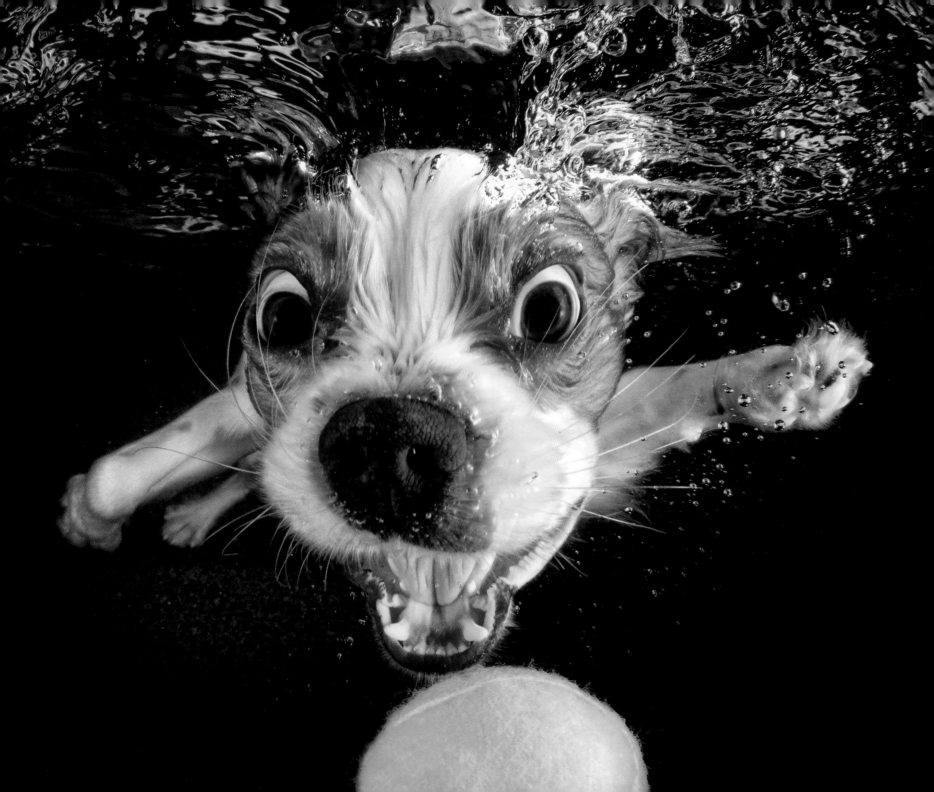

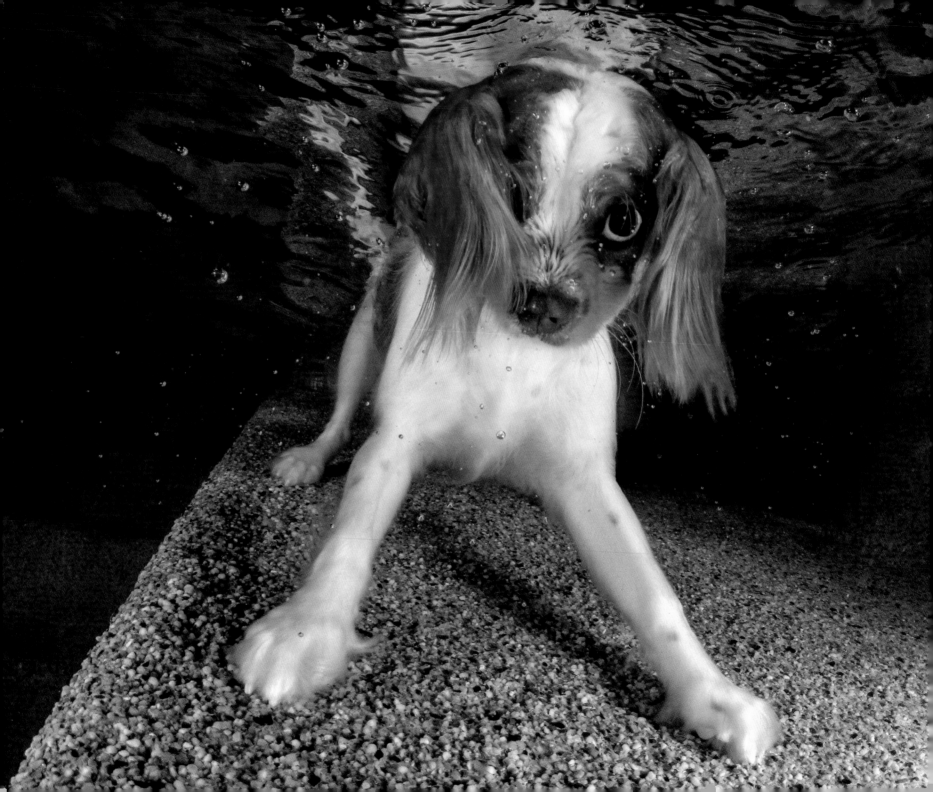

BRANDO American Pit Bull Terrier, 8 weeks

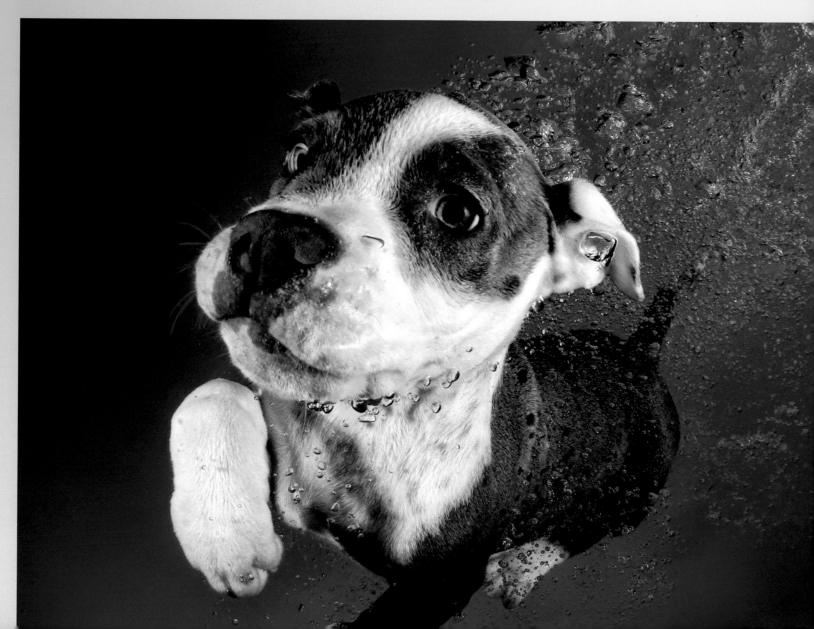

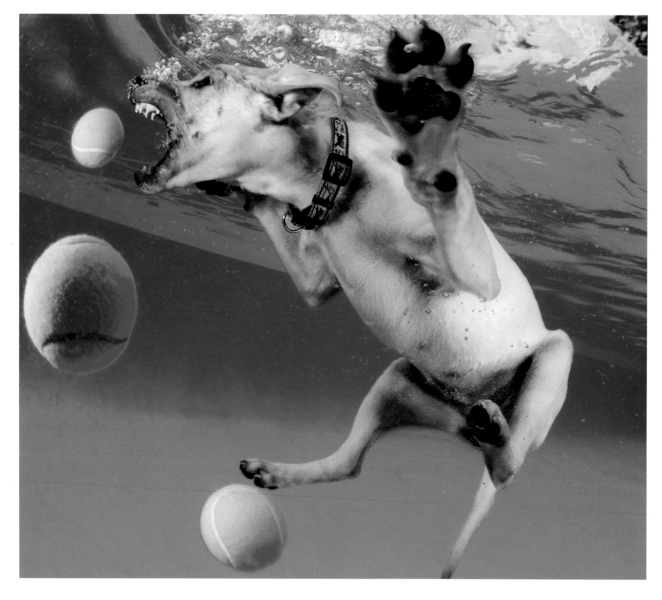

GRITS Yellow Labrador Retriever, 12 weeks

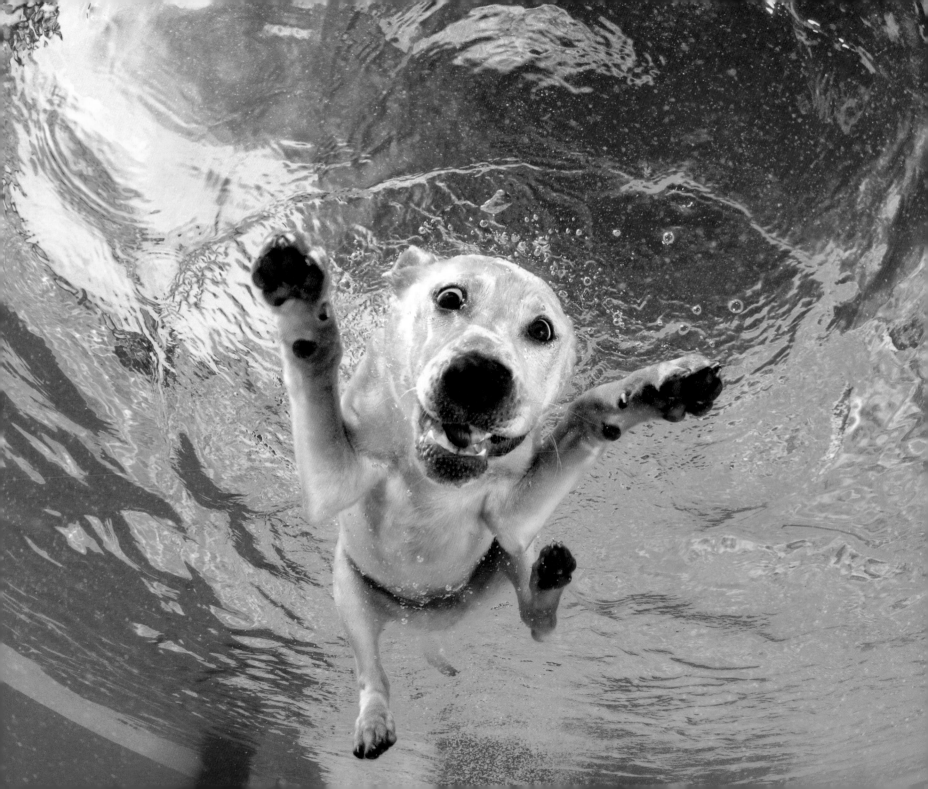

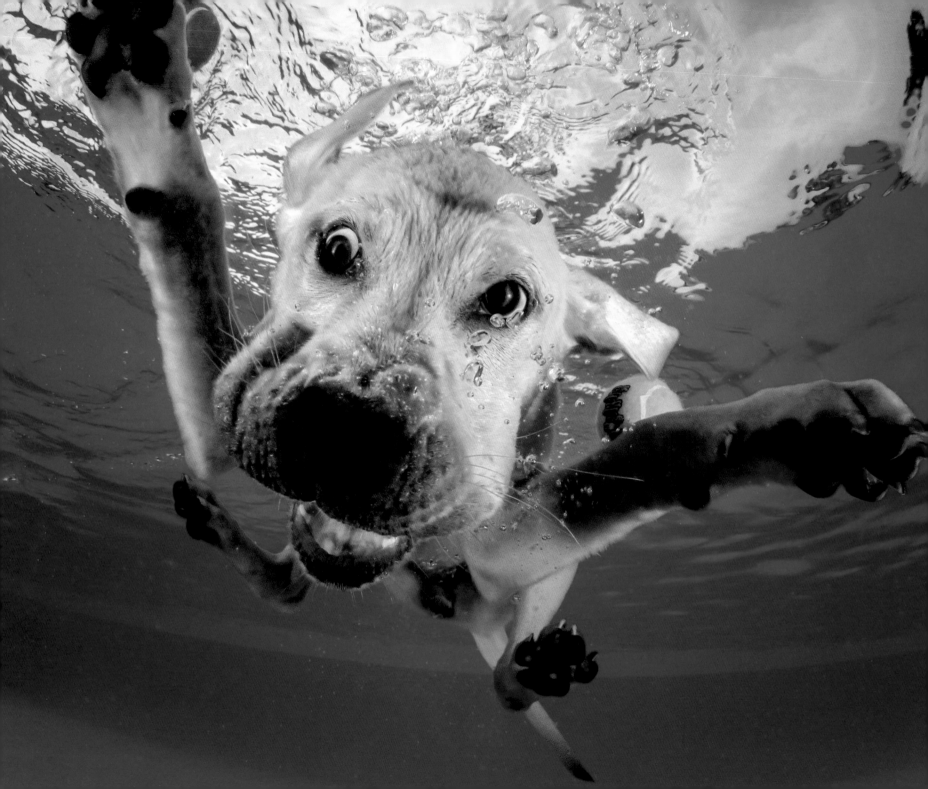

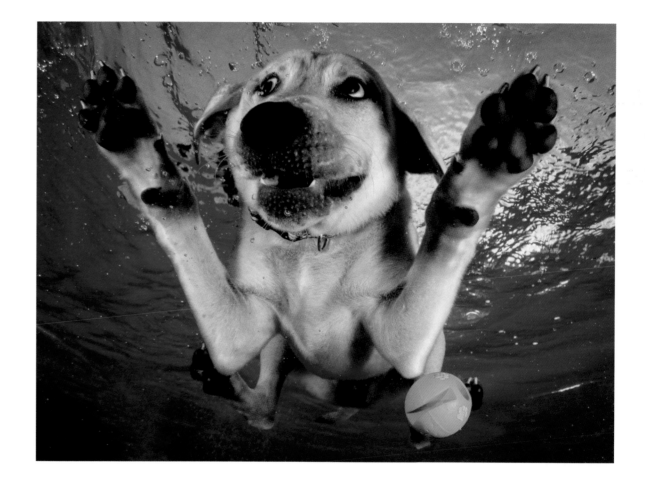

HIPPIE Dalmatian, 6 months

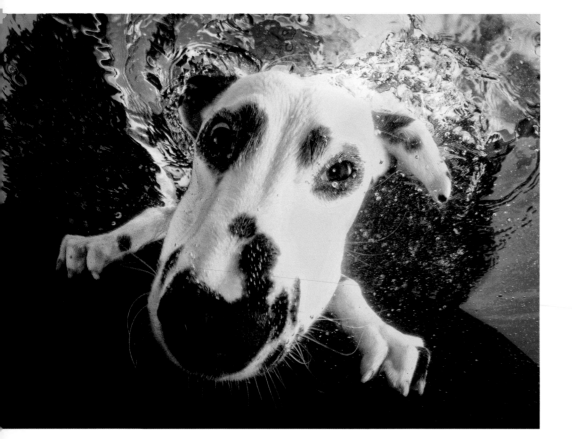

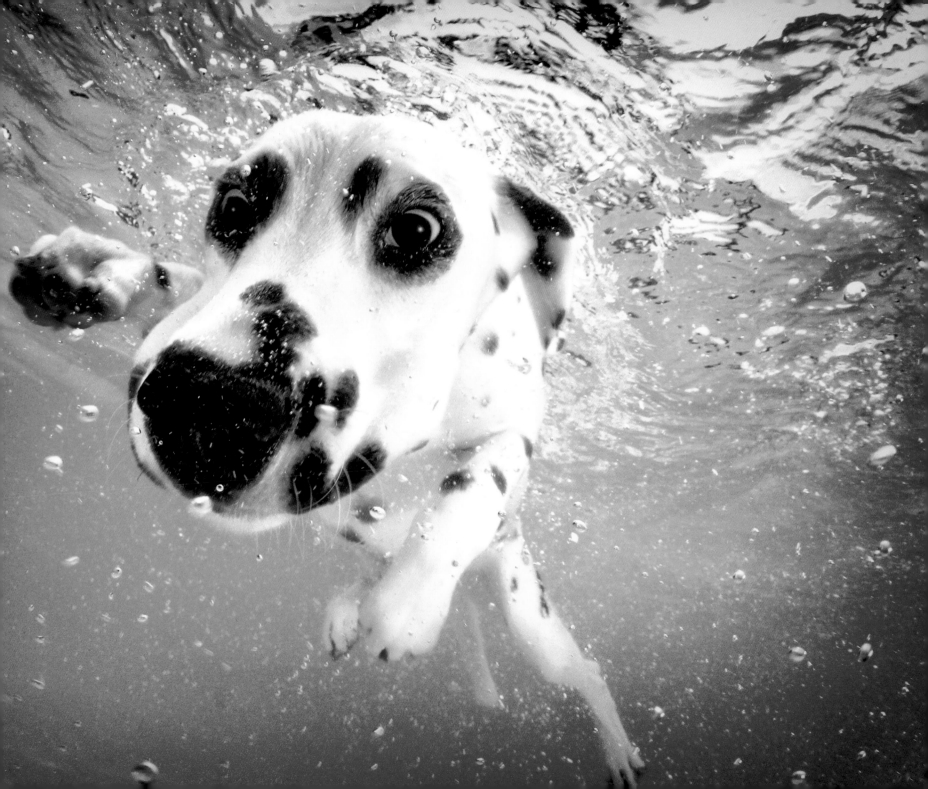

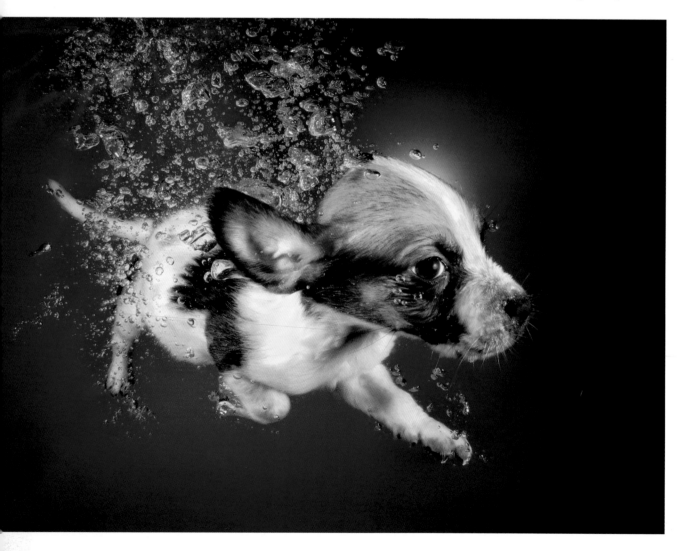

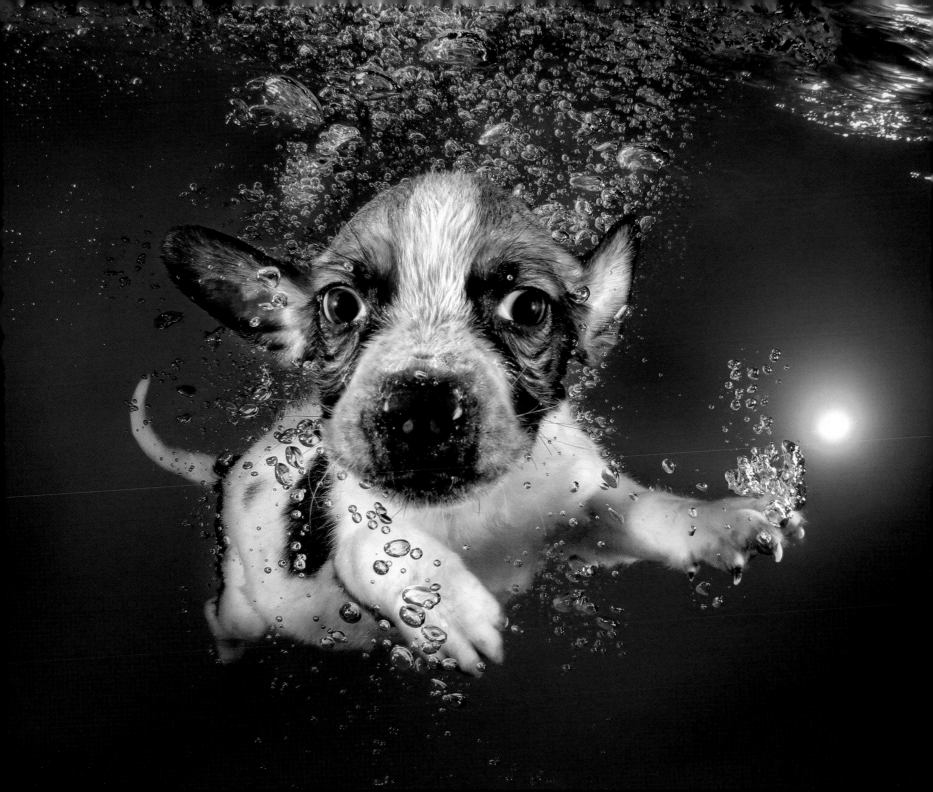

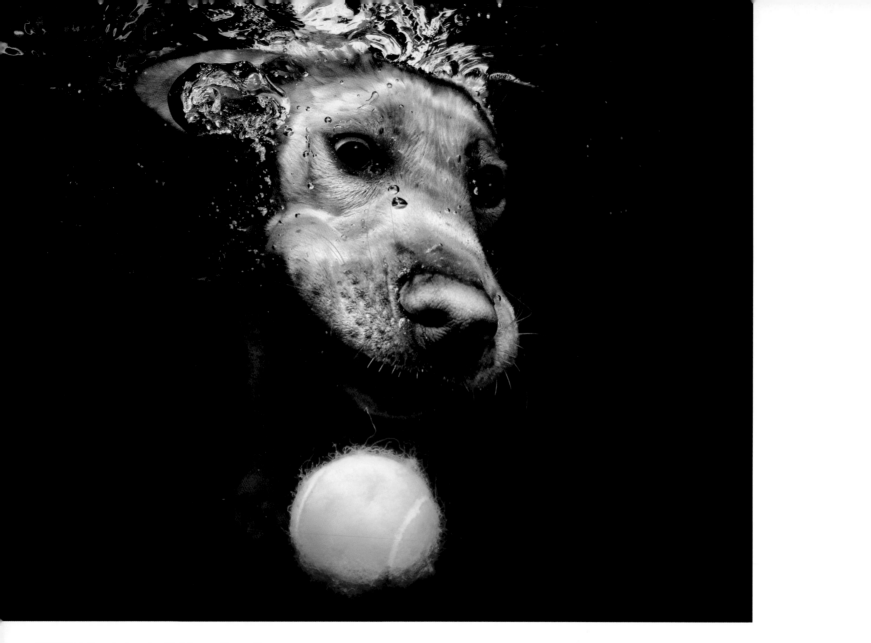

TITAN Yellow Labrador Retriever, 5 months

DAPHNE Cavalier King Charles Spaniel, 16 weeks

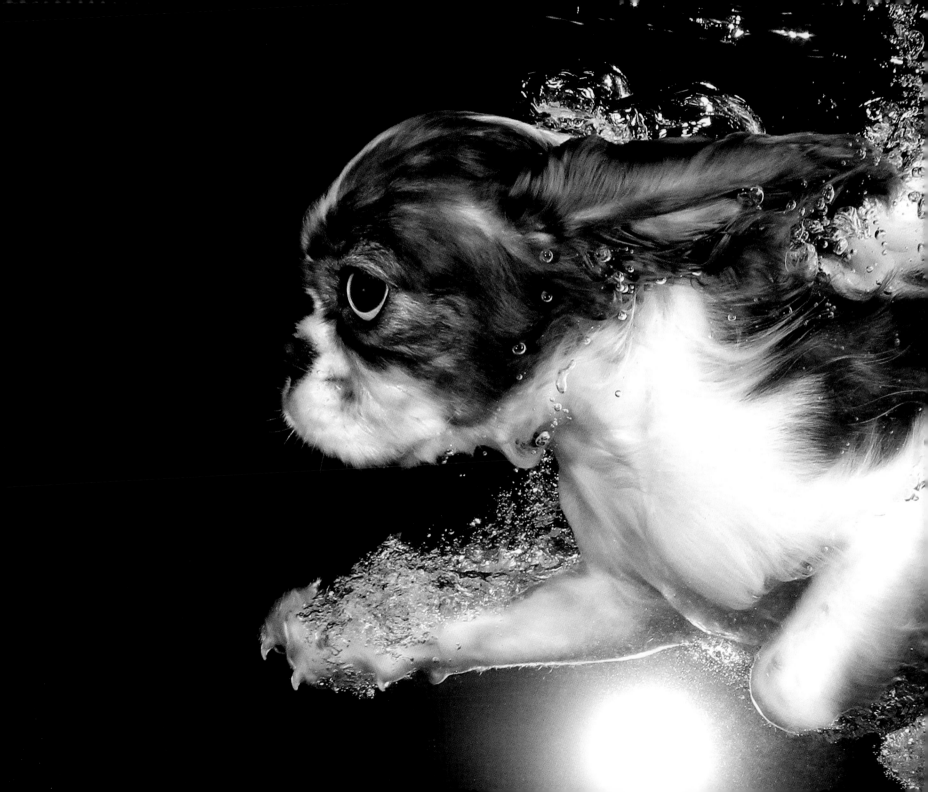

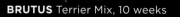

BRUTUS Terrier Mix, 10 weeks

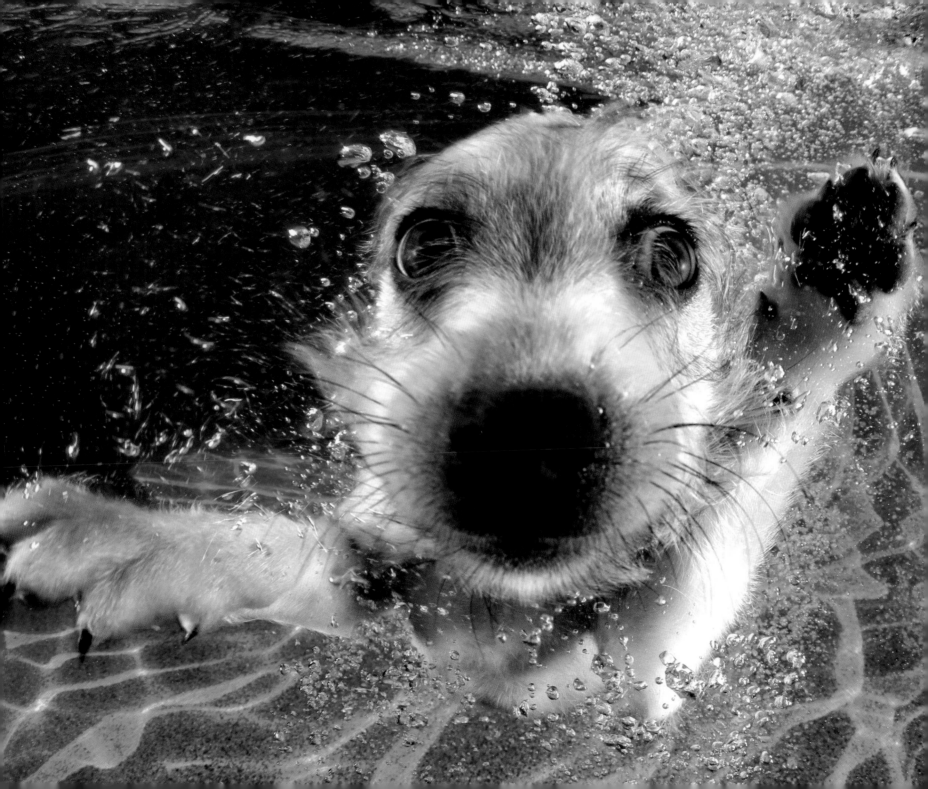

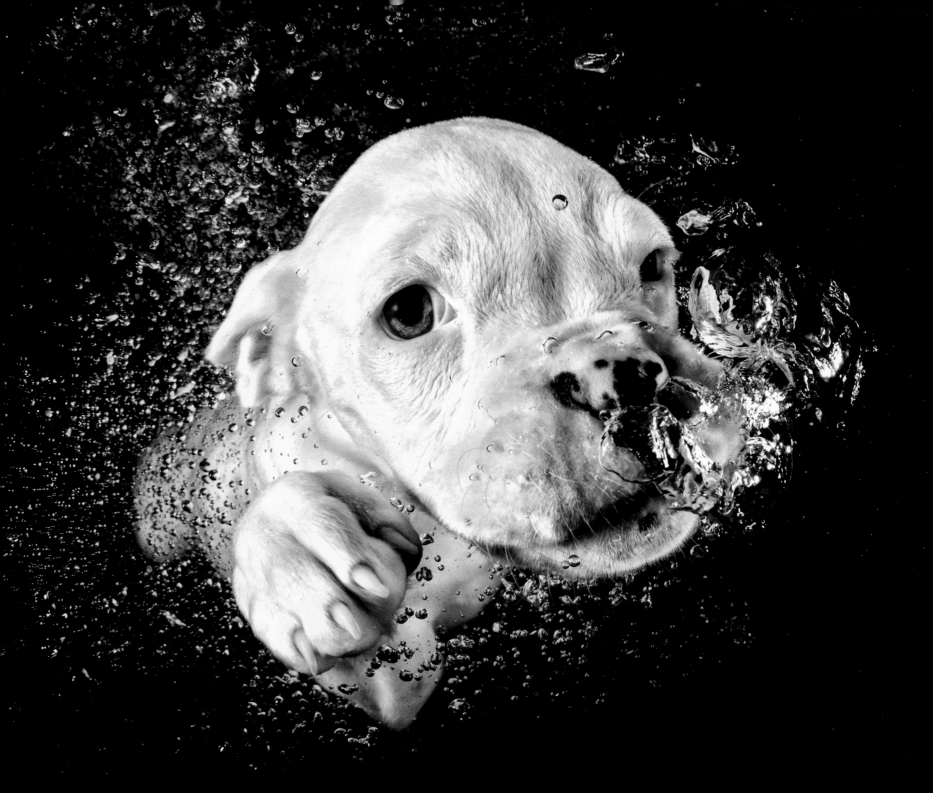

SUGAR Boxer, 7 weeks

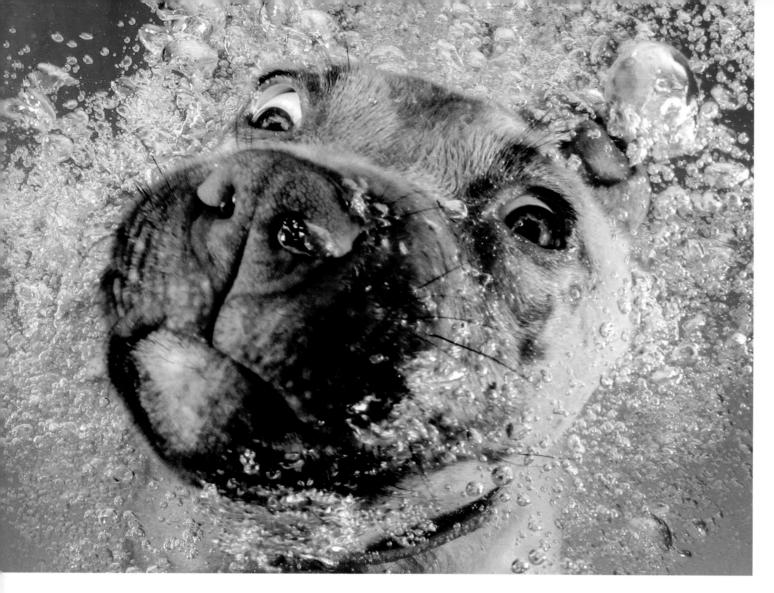

EMMY American Pit Bull Terrier, 14 weeks

CLYDE Black Labrador Retriever/Staffordshire Terrier, 16 weeks

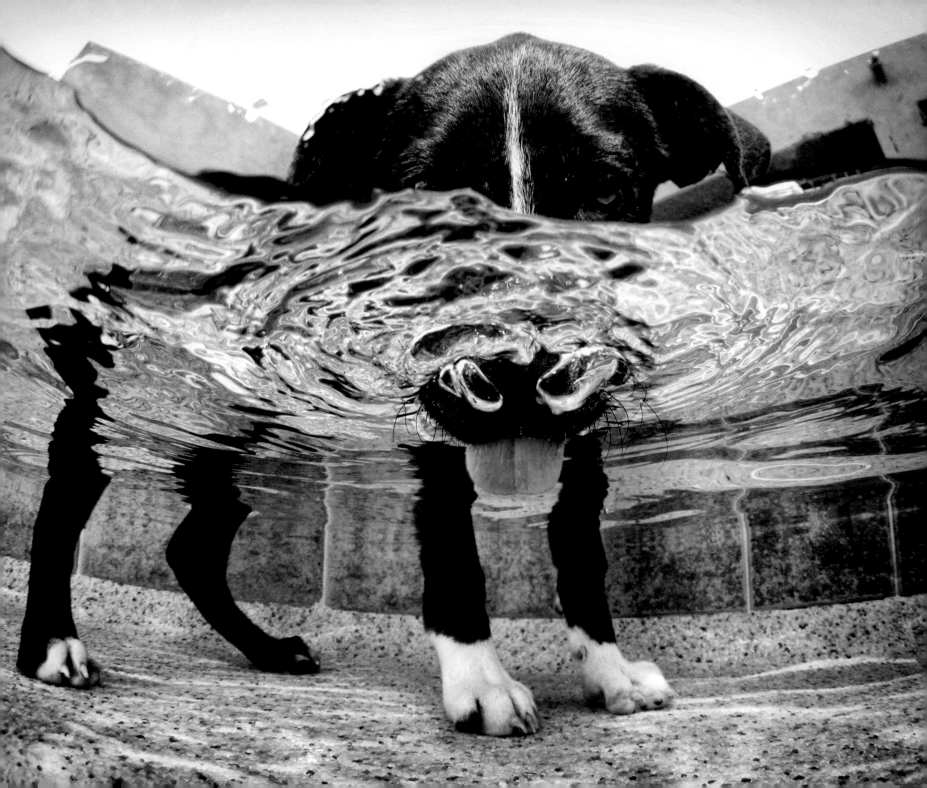

ORBIT Cavalier King Charles Spaniel, 10 weeks

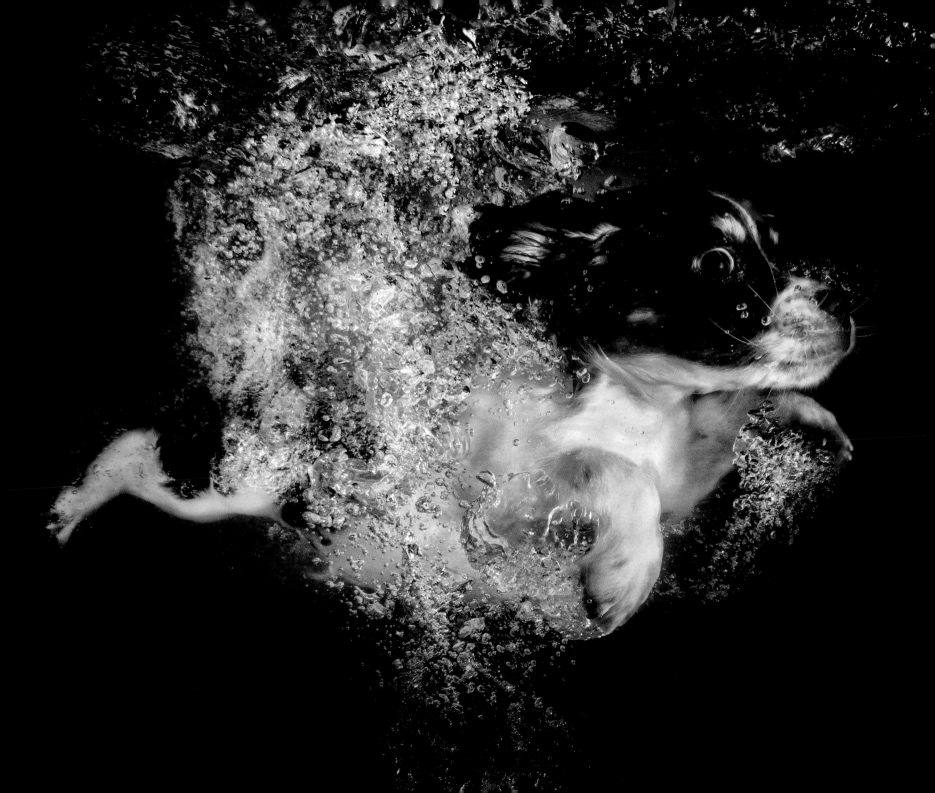

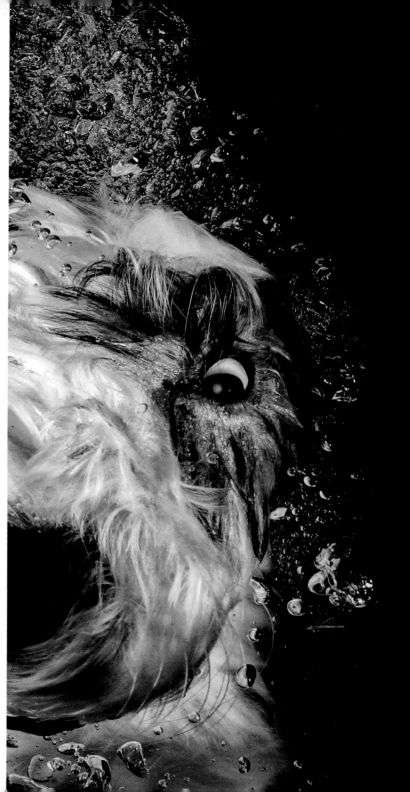

HAYMISH Old English Sheepdog, 10 weeks

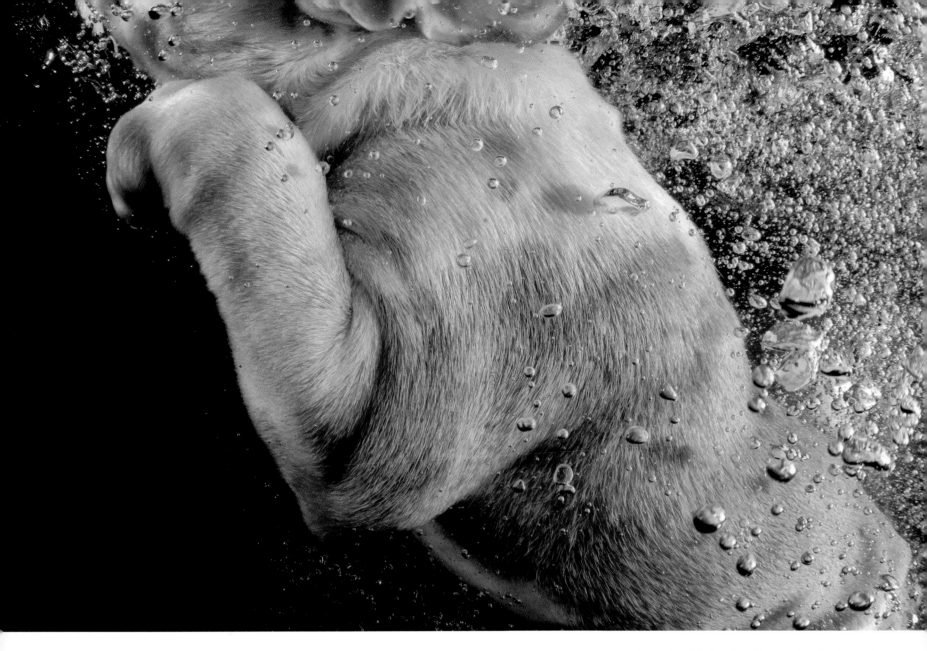

LUMPKIN English Bulldog/Boston Terrier, 18 weeks

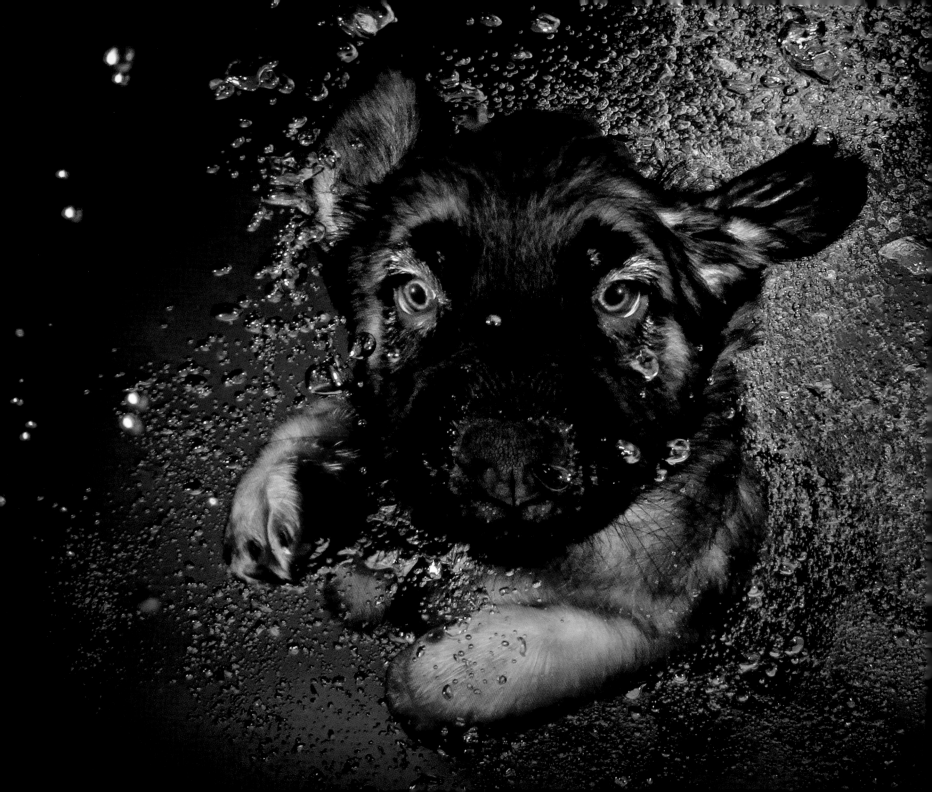

RAMONA German Shepherd Mix, 9 weeks

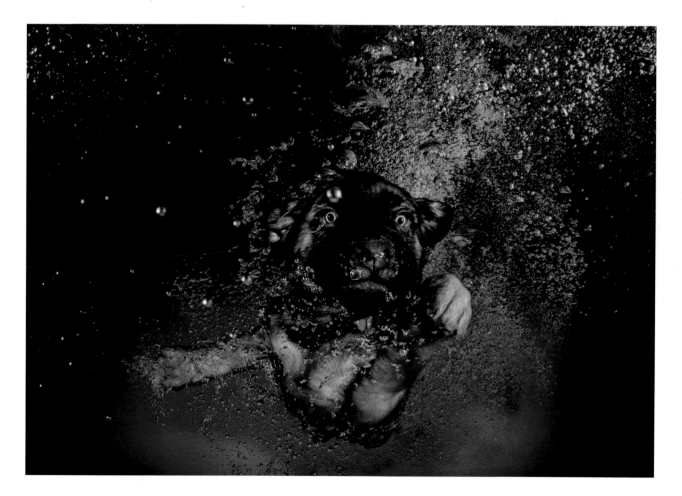

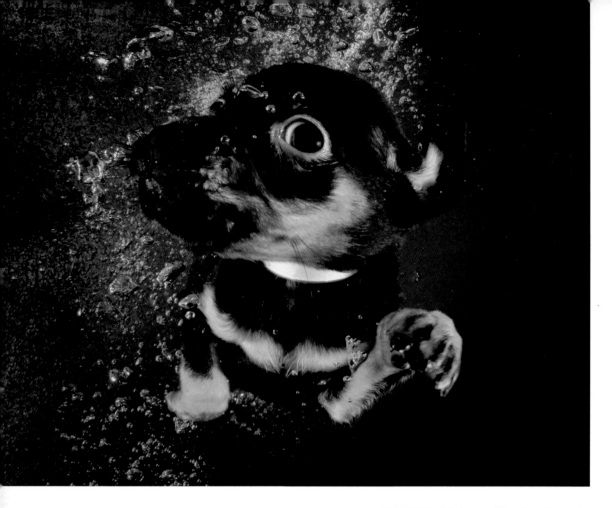

MALCOLM Miniature Pinscher, 9 weeks

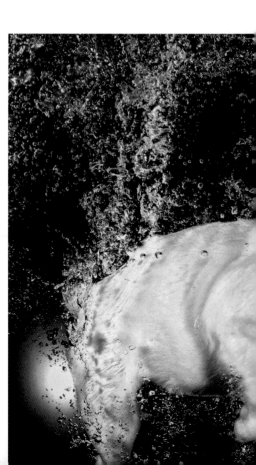

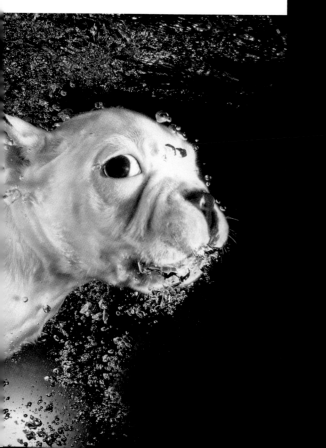

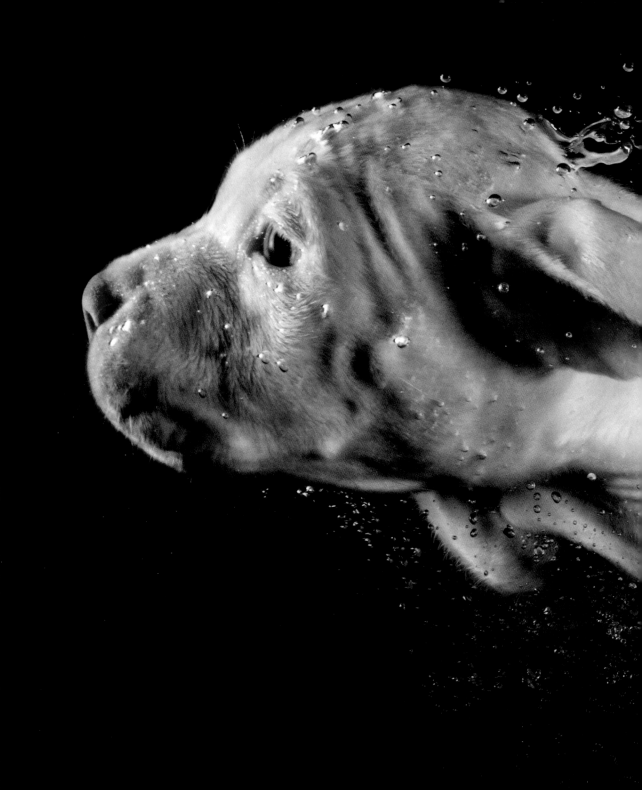

PIERRE American Pit Bull Terrier, 7 weeks

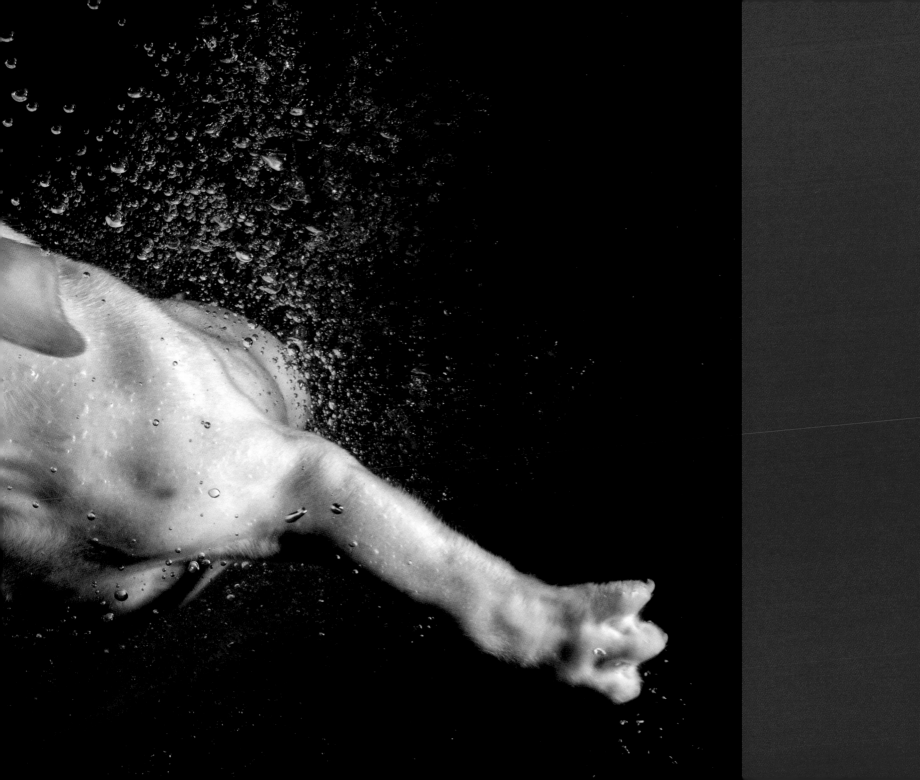

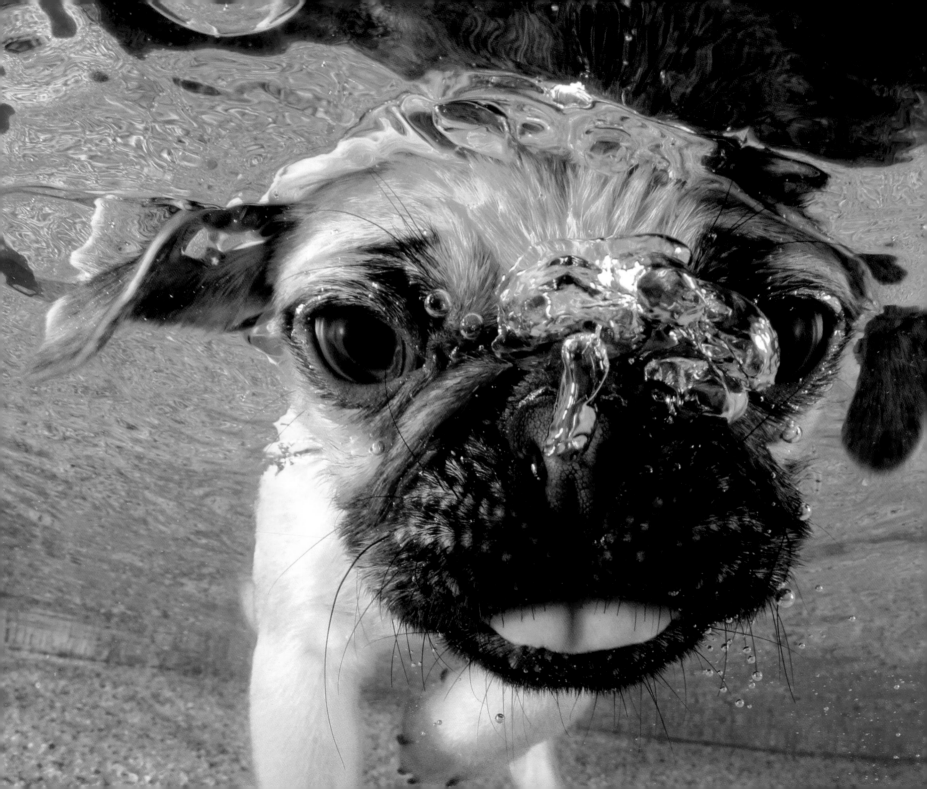

IGGY Pug, 15 weeks

PLUTO Italian Greyhound, 18 weeks

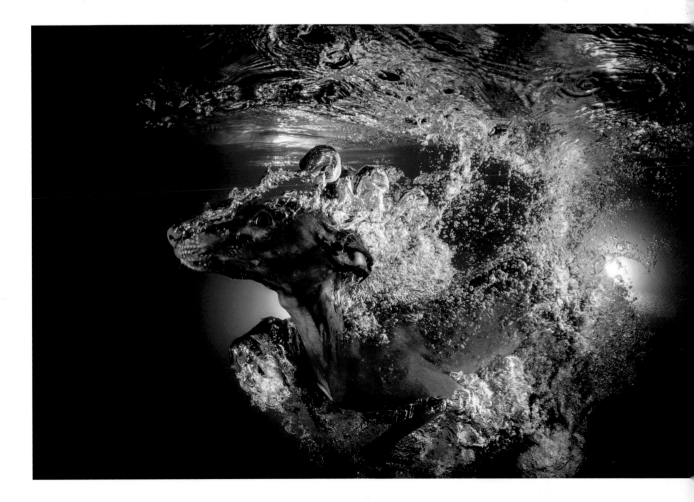

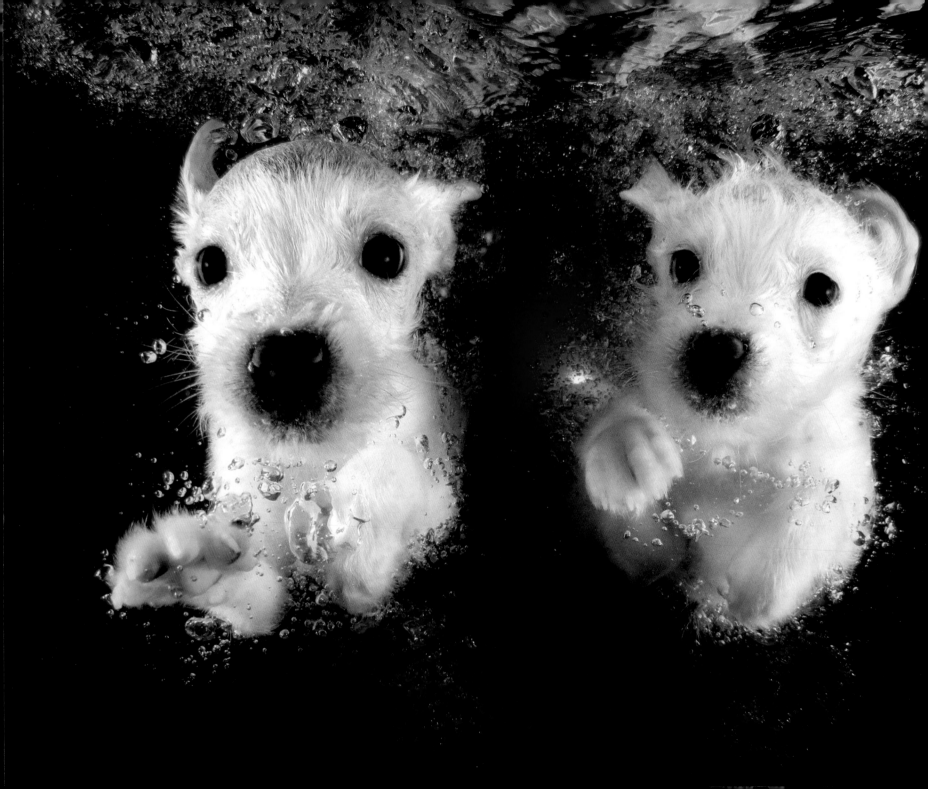

PRINGLES and **PICKME** Terrier Mixes, 8 weeks

PRINGLES Terrier Mix, 8 weeks

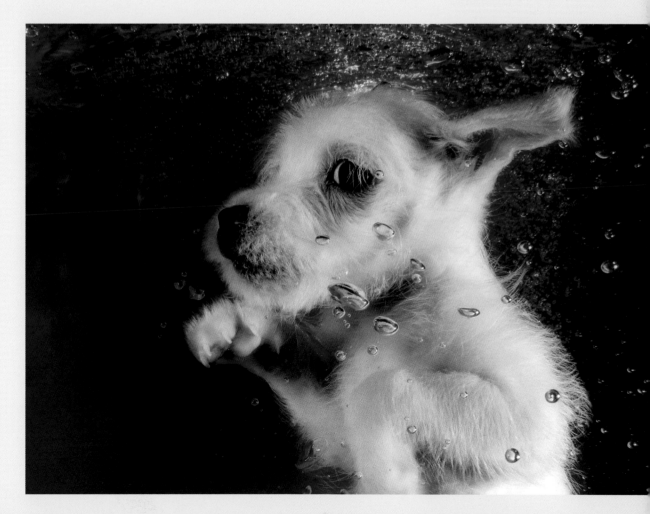

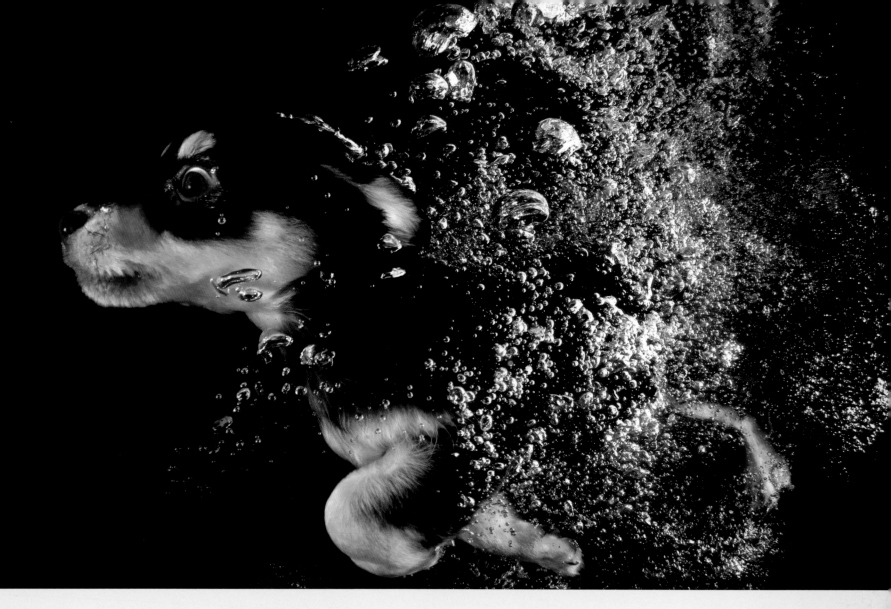

ROLLEY Terrier Mix, 10 weeks

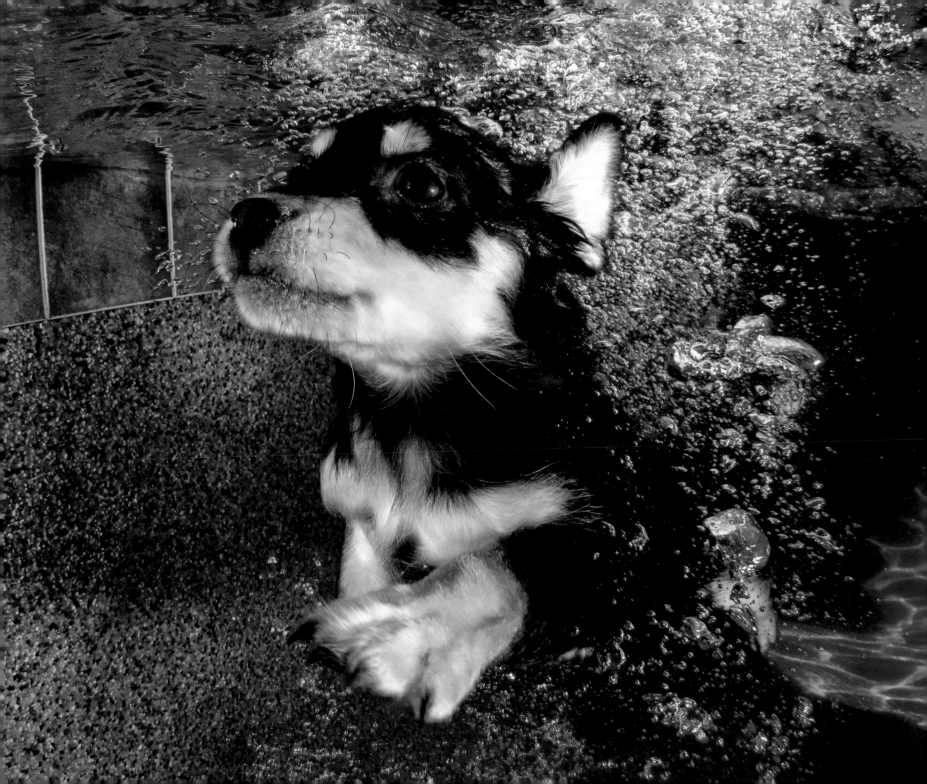

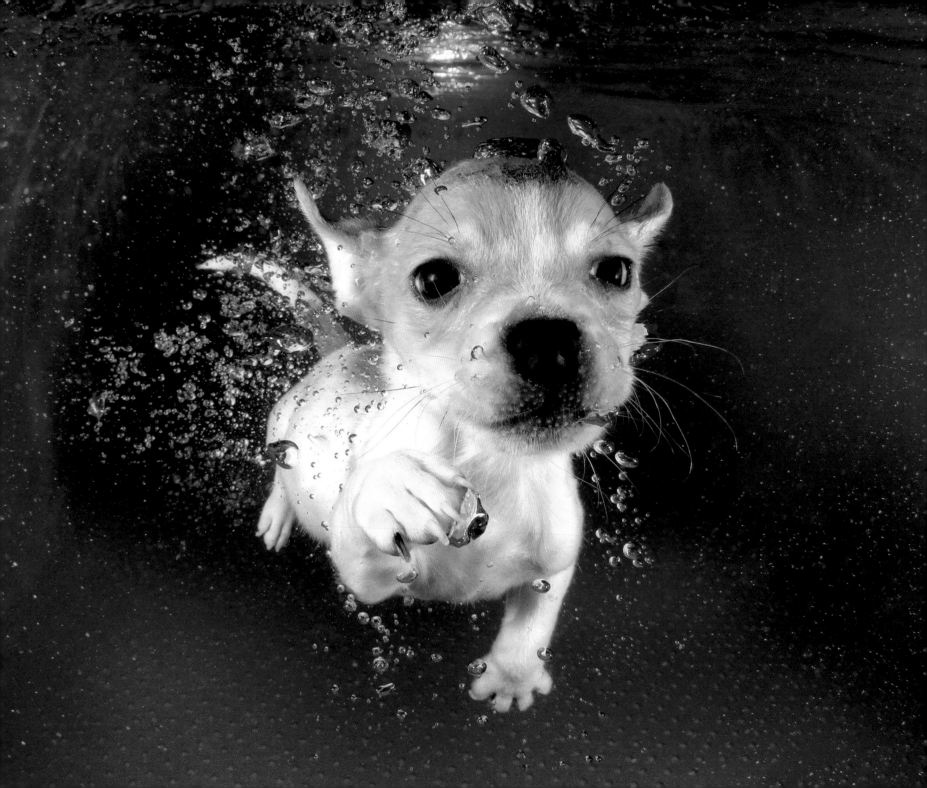

CARU Chihuahua Mix, 6 weeks

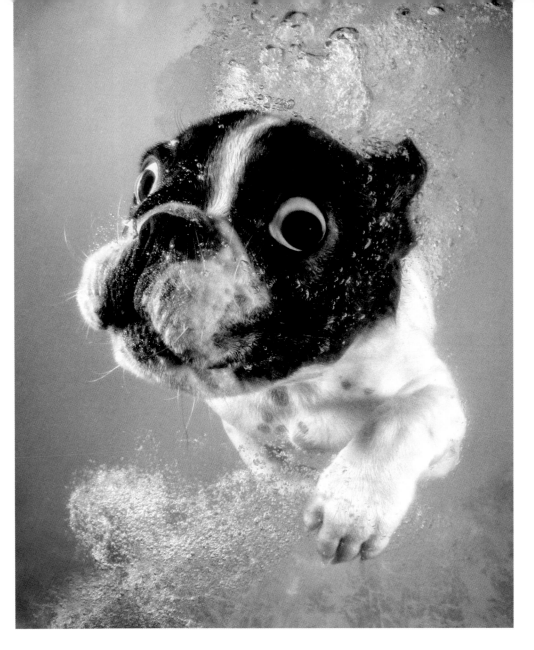

BENTLEY French Bulldog, 16 weeks

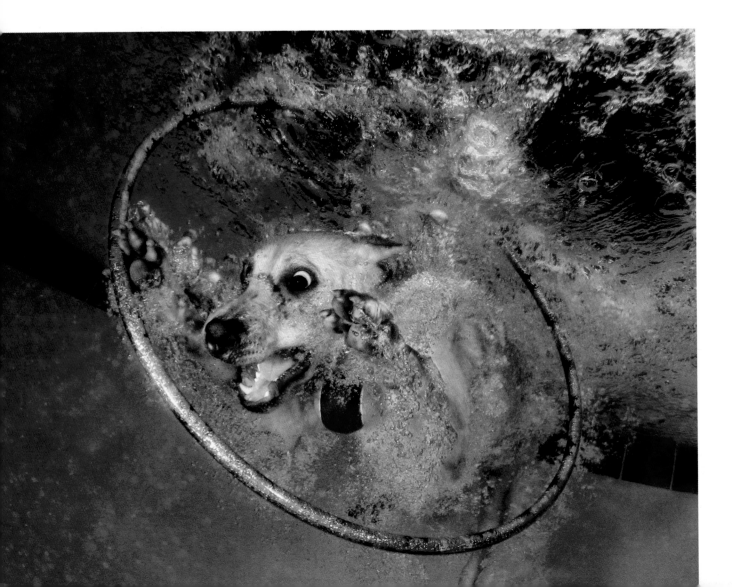

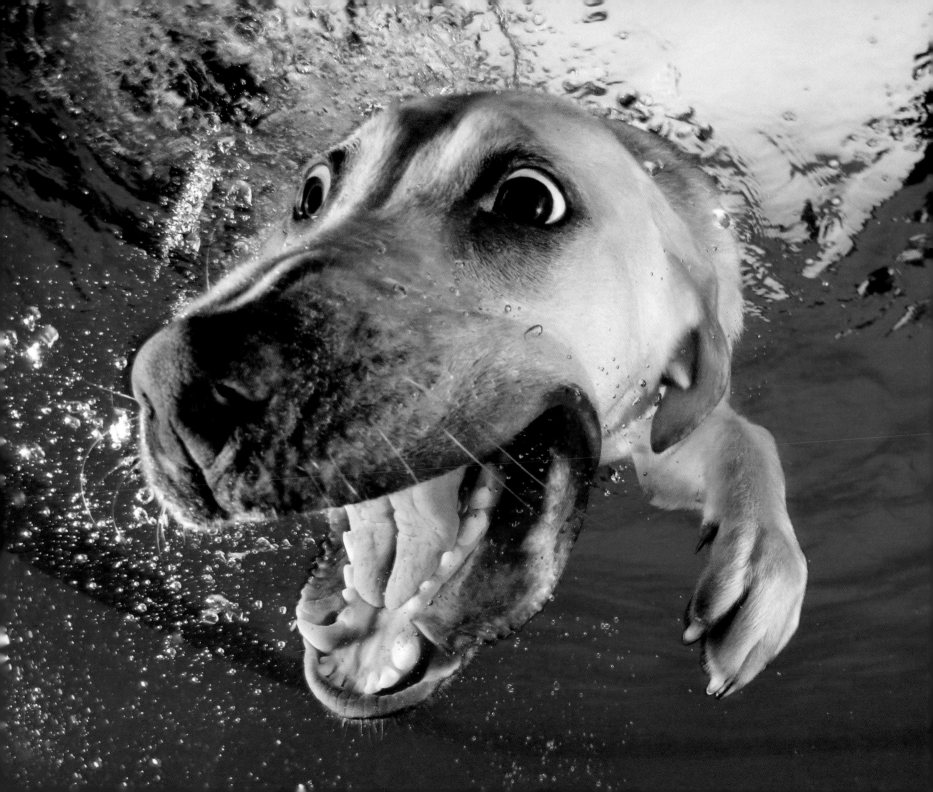

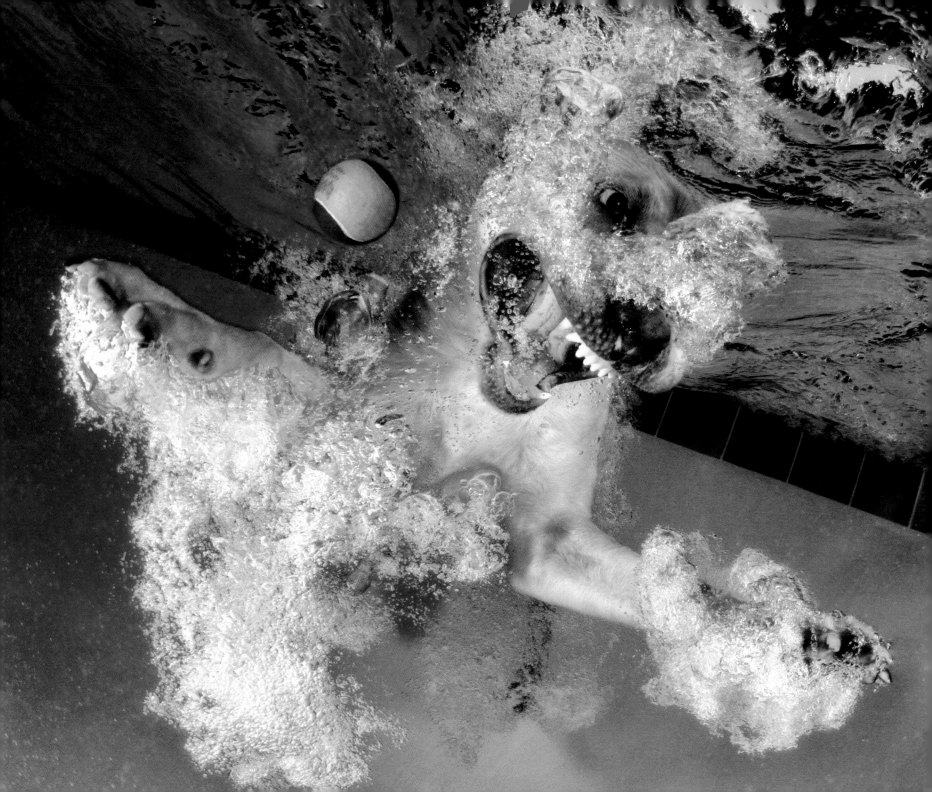

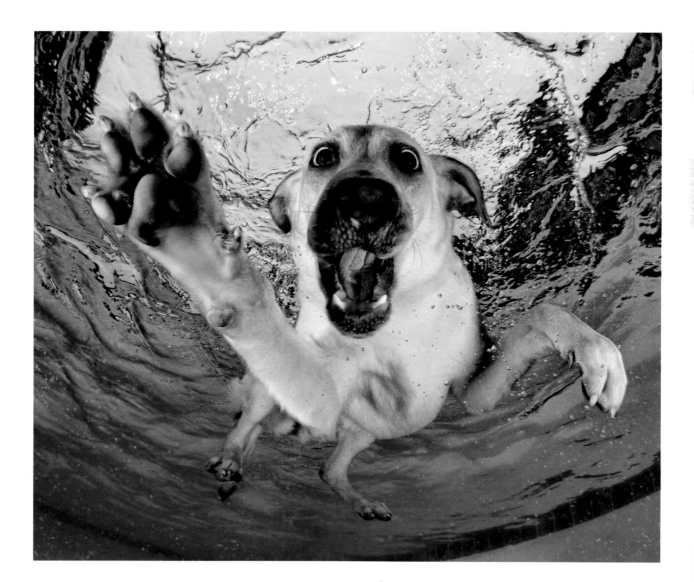

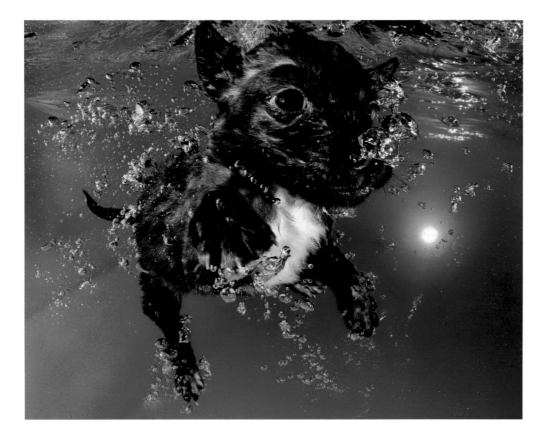

GRIZZLE Chihuahua Mix, 6 weeks

BUTTERBALL Saint Bernard, 8 weeks

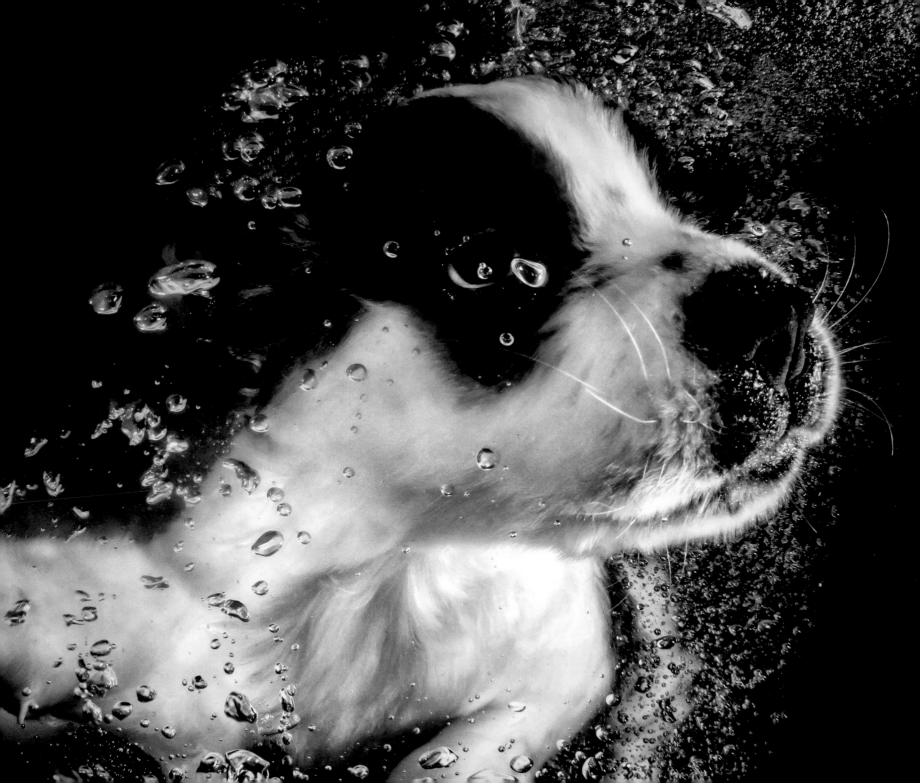

COREY Labrador Retriever/Australian Cattle Dog, 8 weeks

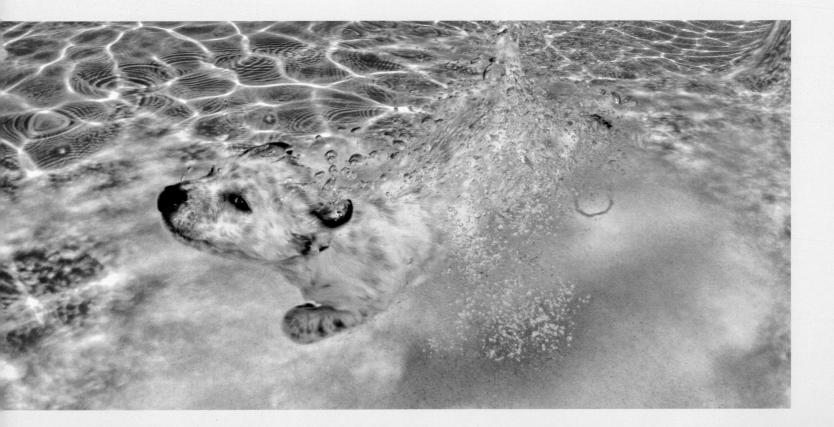

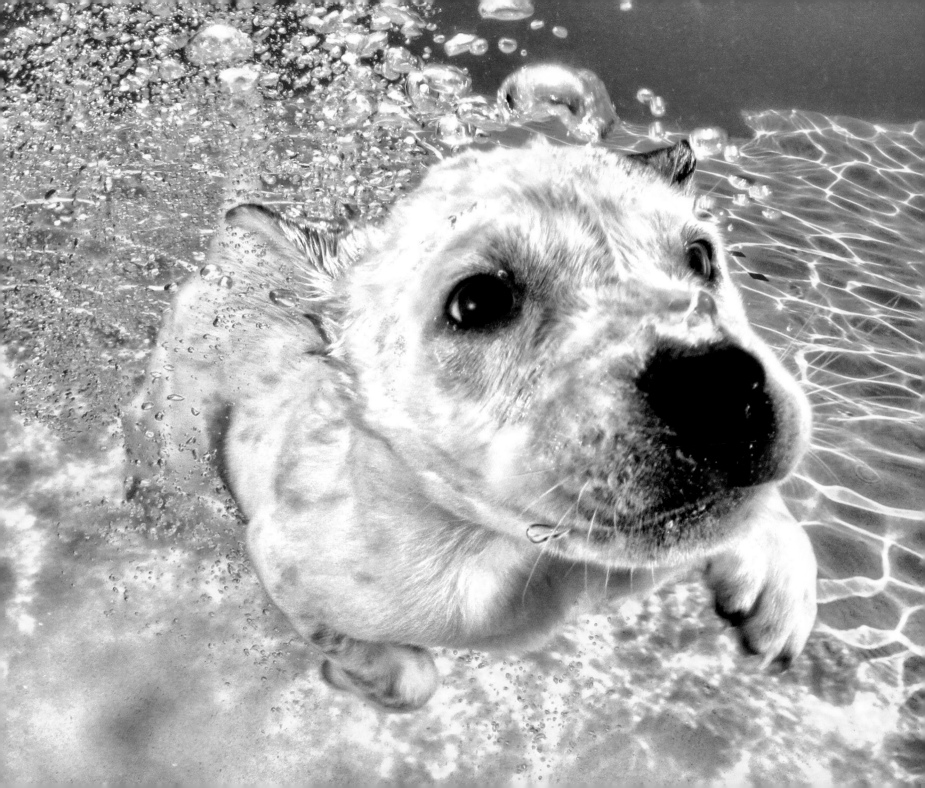

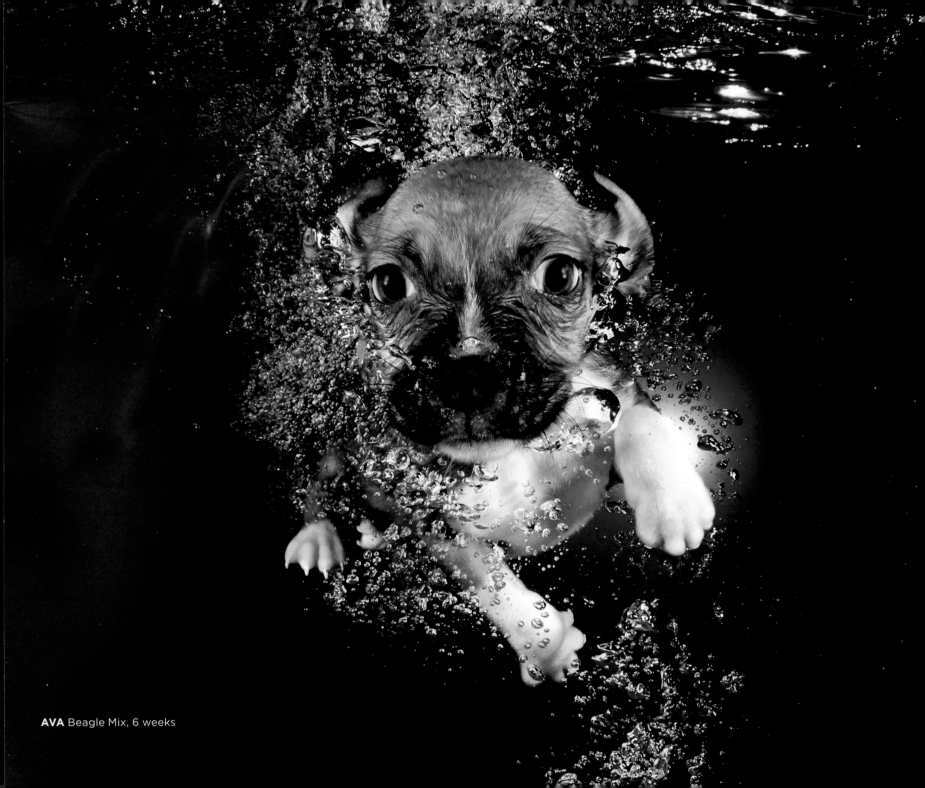

AVA Beagle Mix, 6 weeks

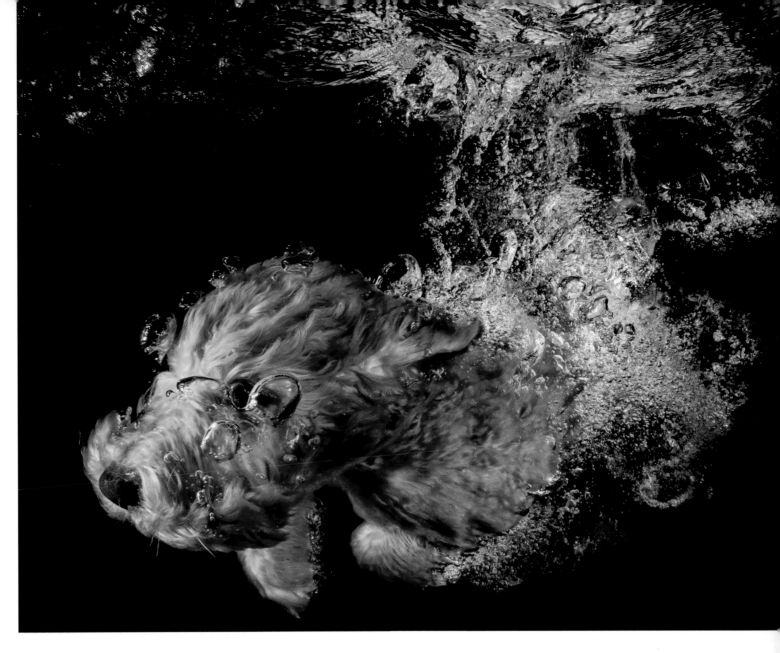

BARCELONA Goldendoodle, 11 weeks

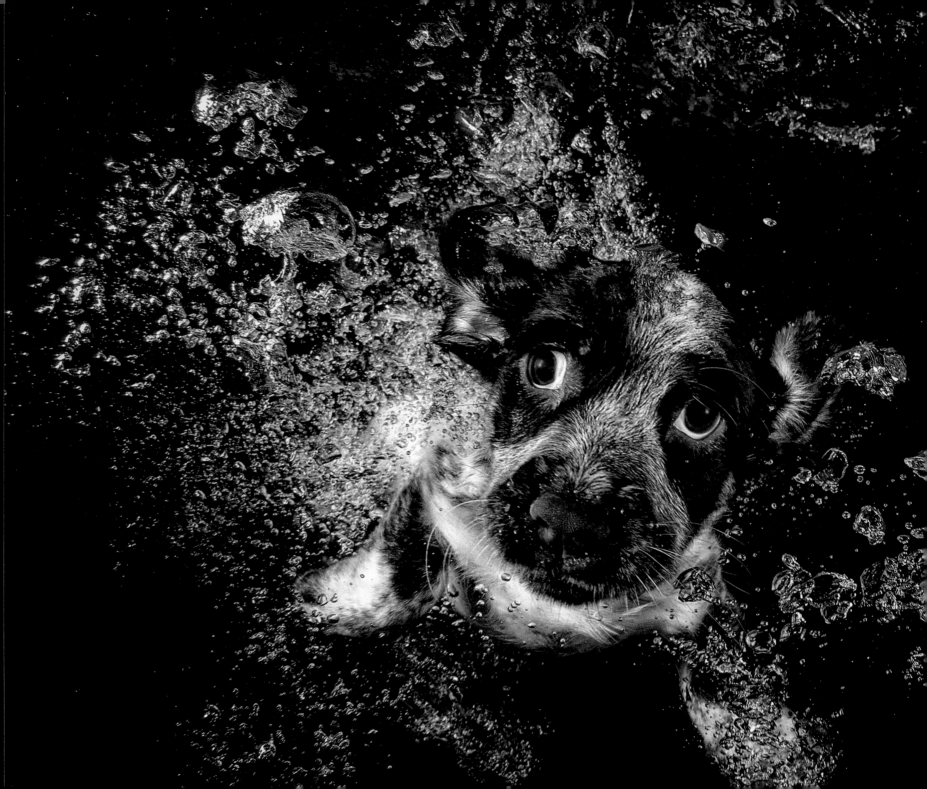

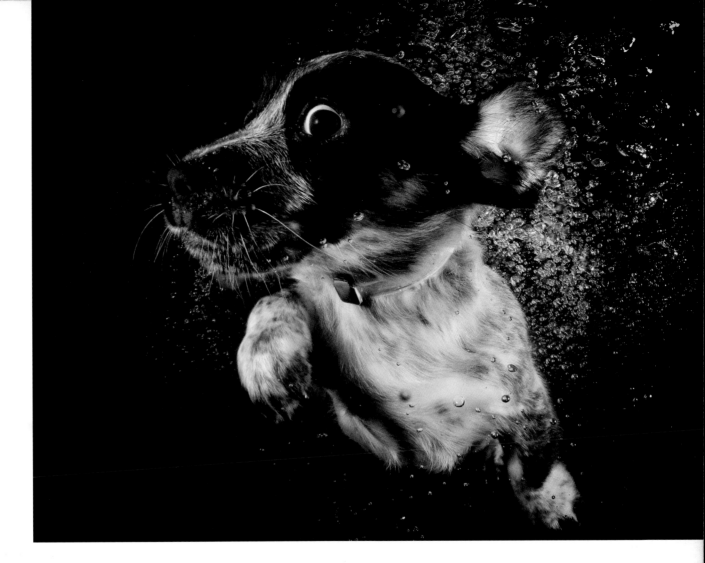

GRACIE Border Collie Mix, 11 weeks

MALONE American Pit Bull Terrier Mix, 10 weeks

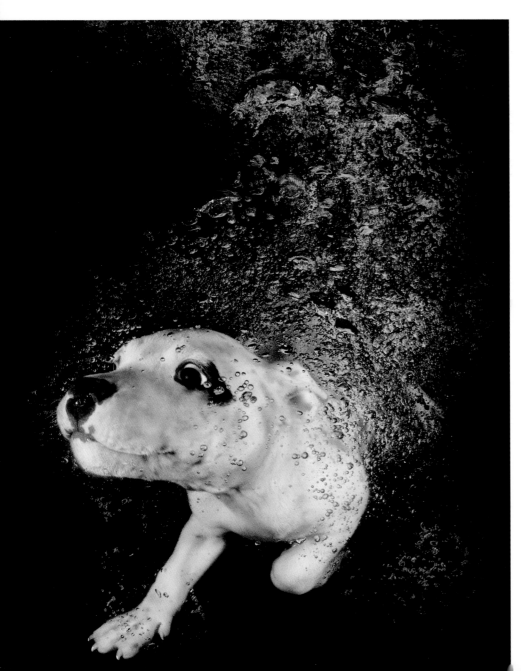

CHEYENNE Golden Retriever, 14 weeks

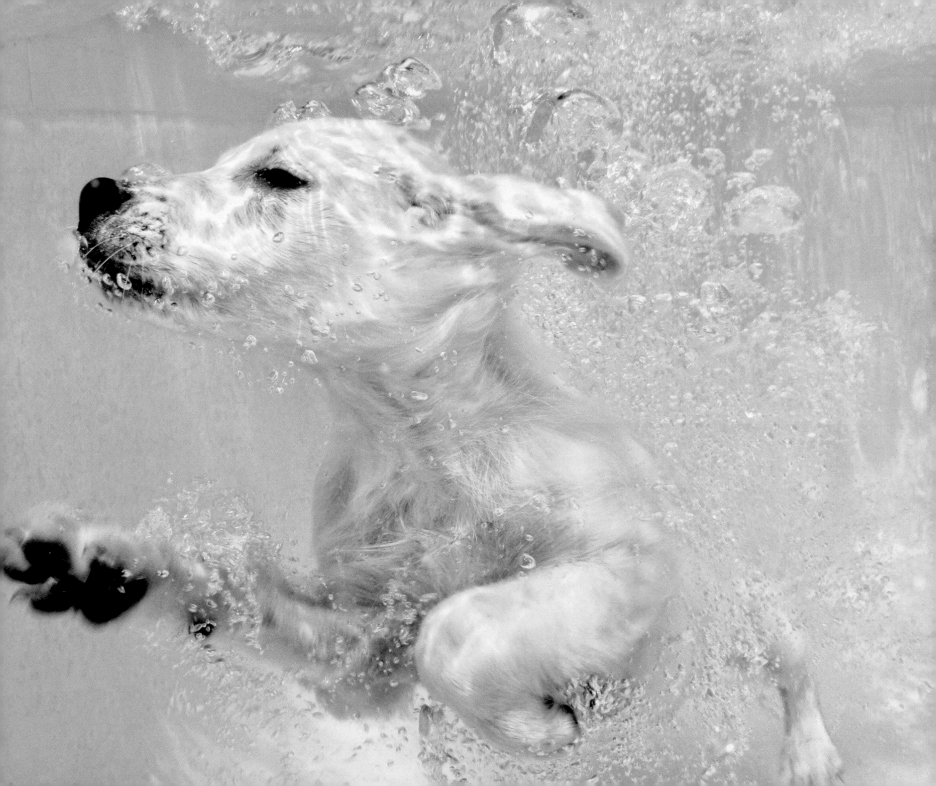

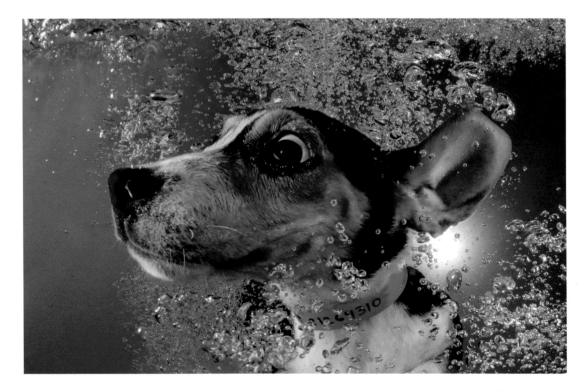

SADIE Basset Hound Mix, 8 weeks

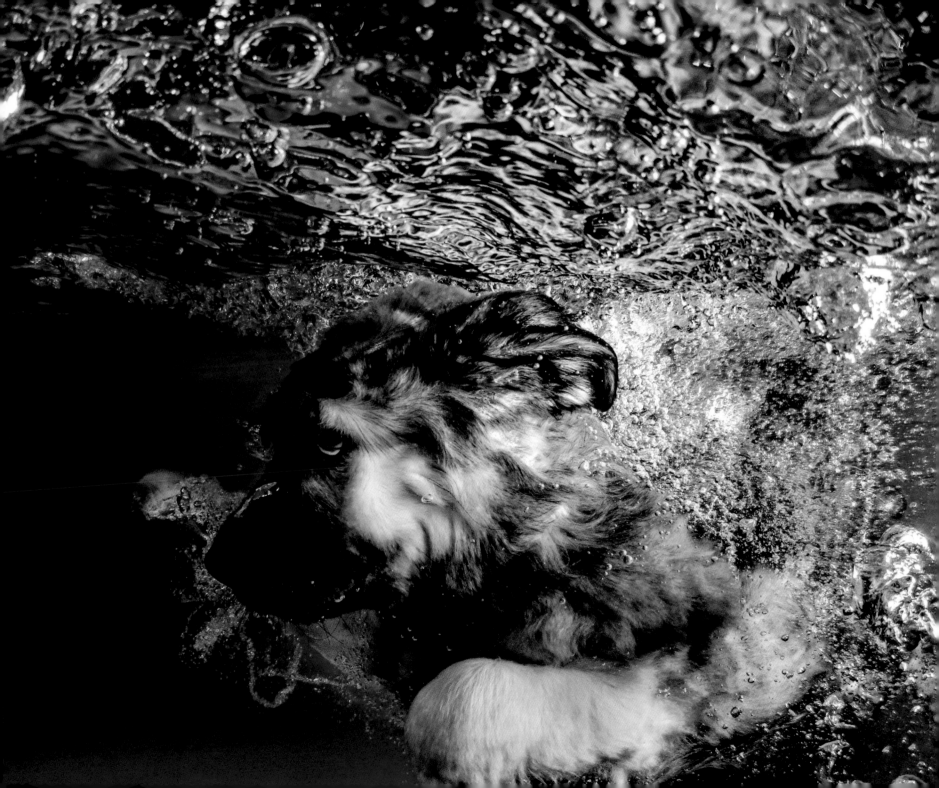

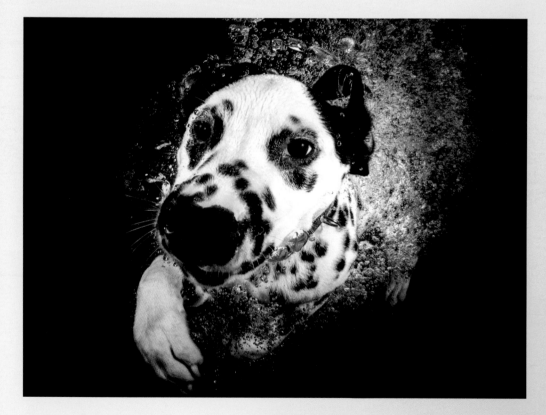

DORA Dalmatian, 16 weeks

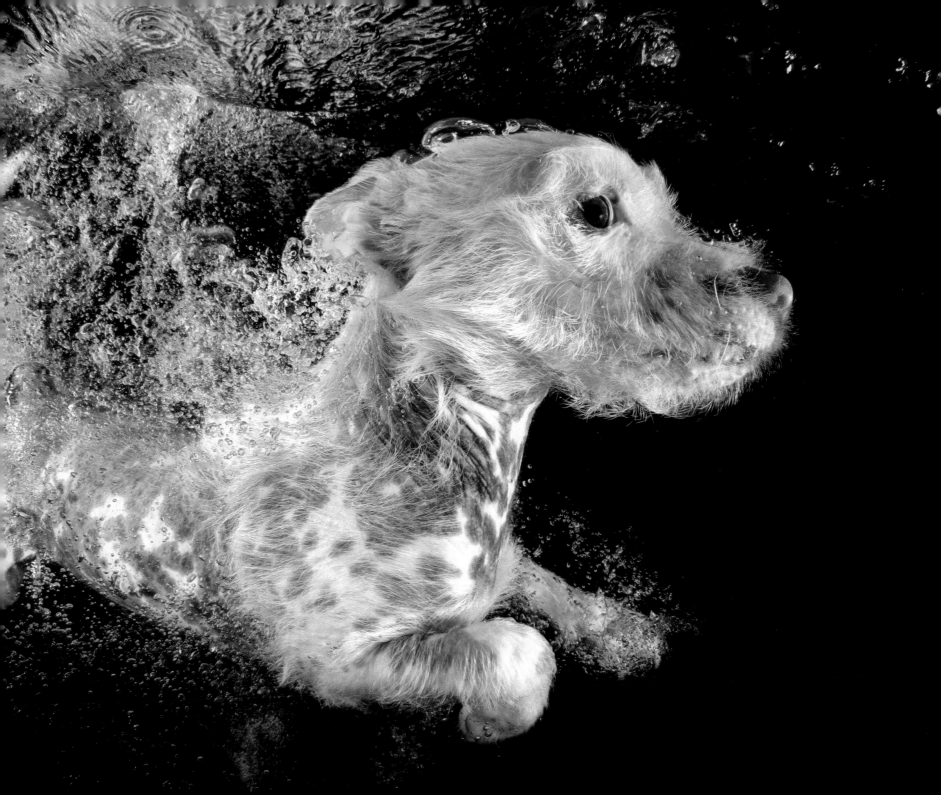

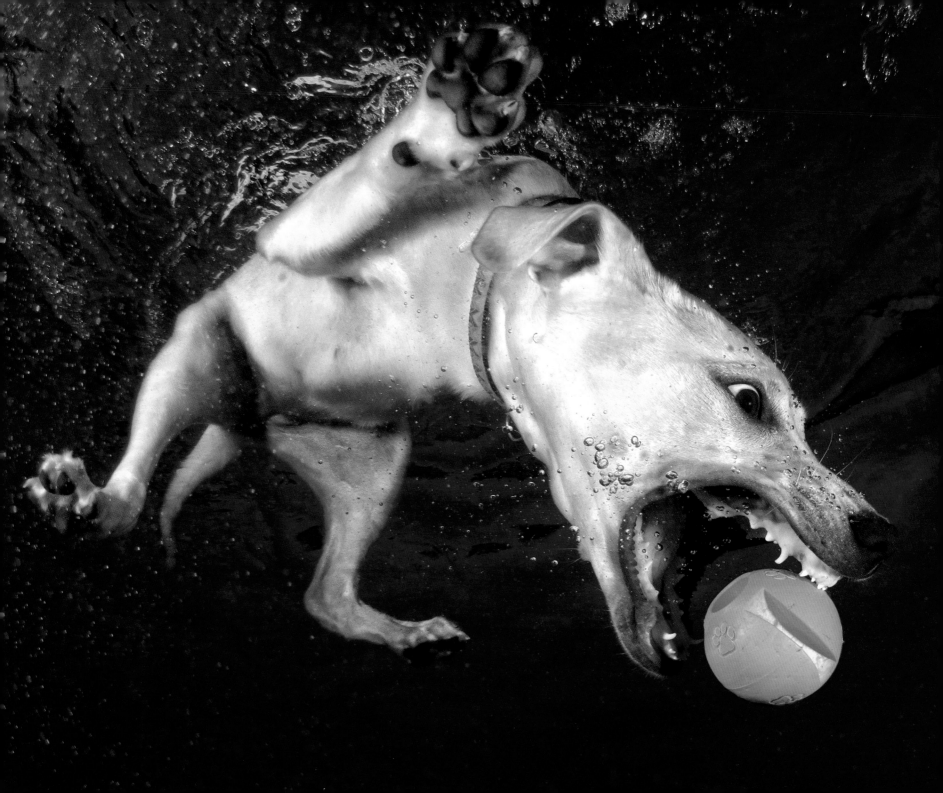

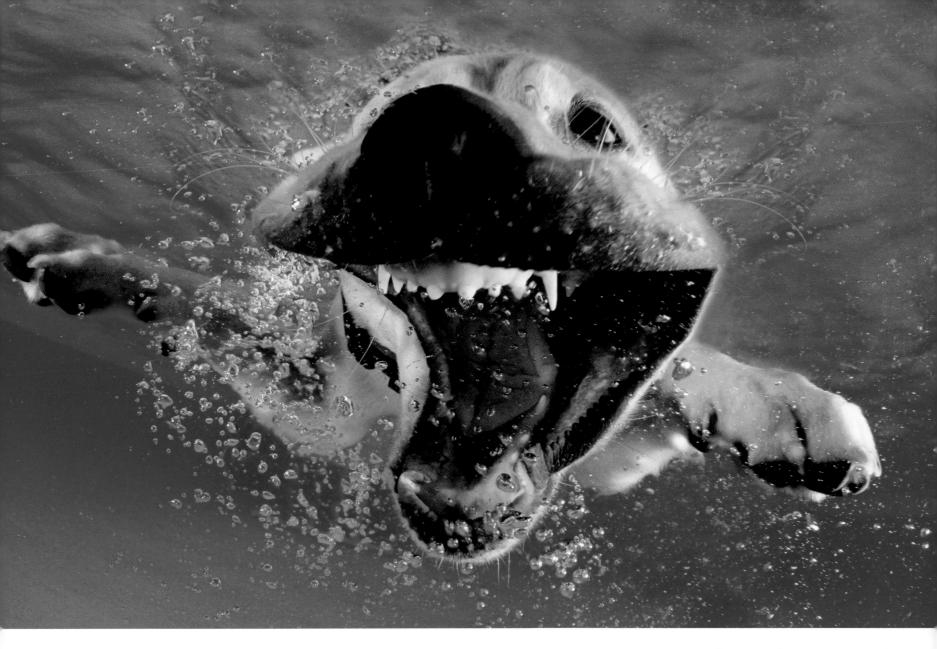

REASON Yellow Labrador Retriever, 12 weeks

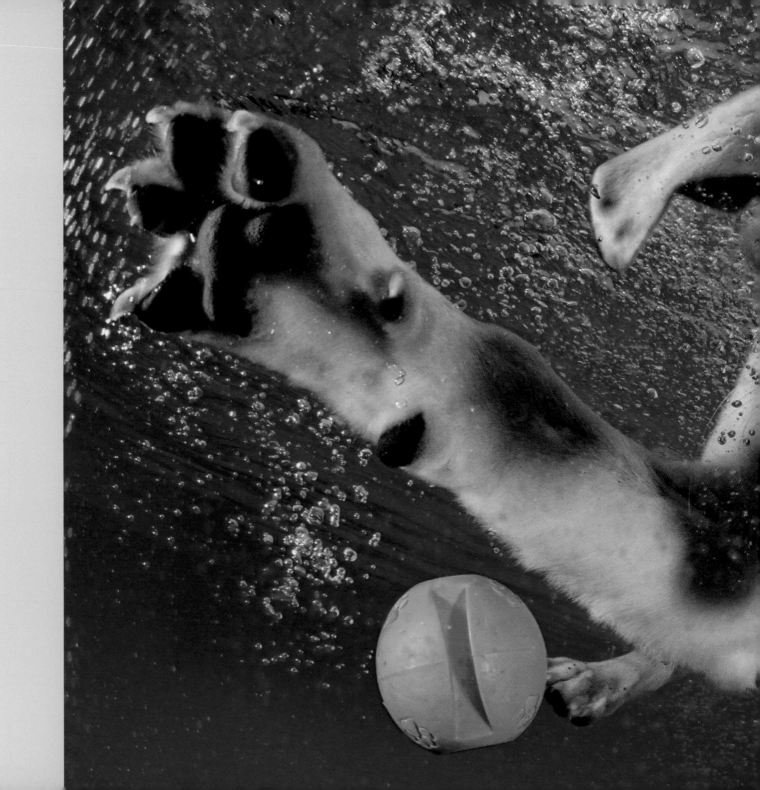

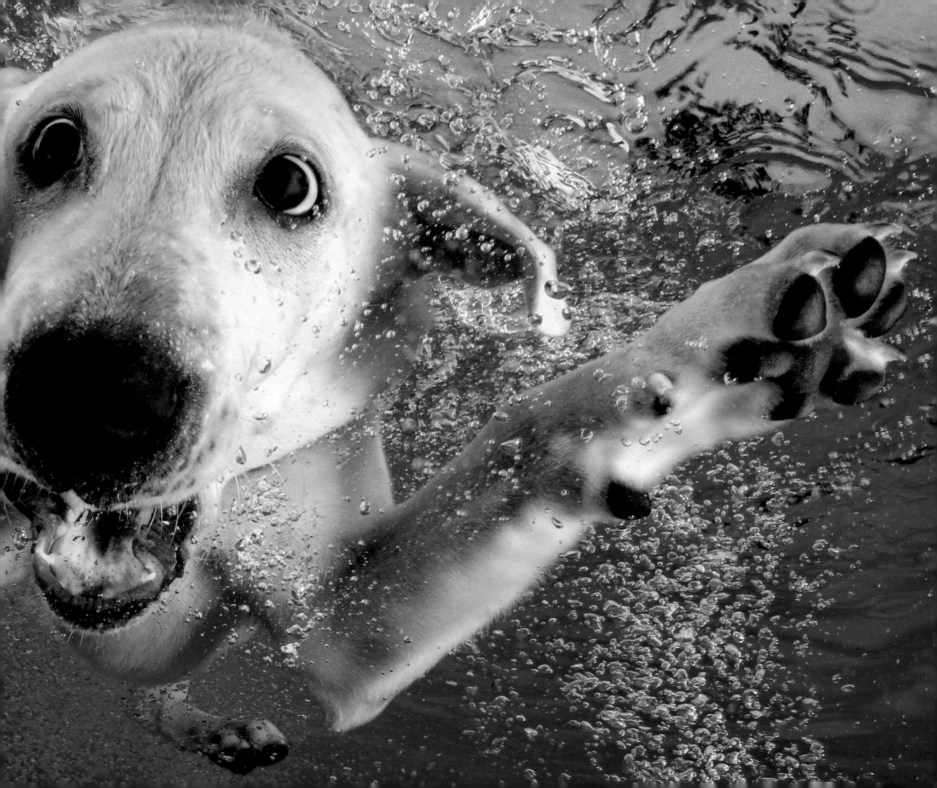

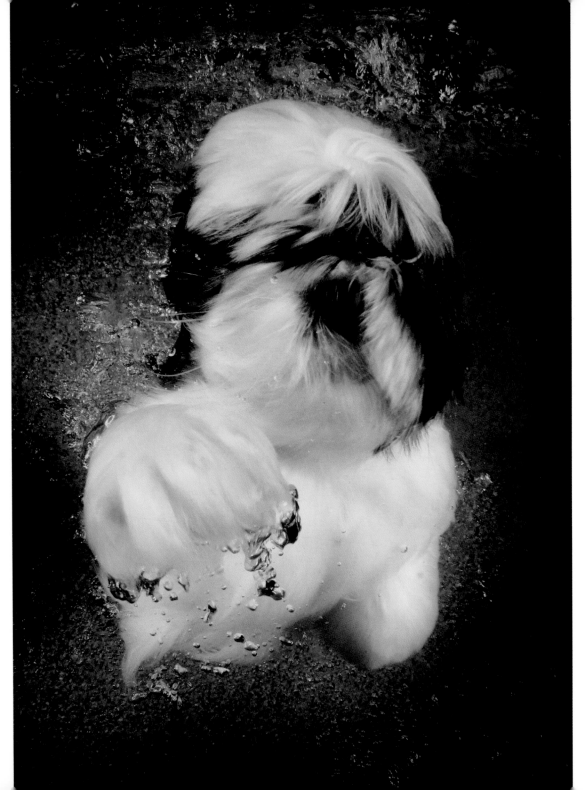

DOUGLAS Shih Tzu, 8 weeks

ASPEN English Bull Terrier, 16 weeks

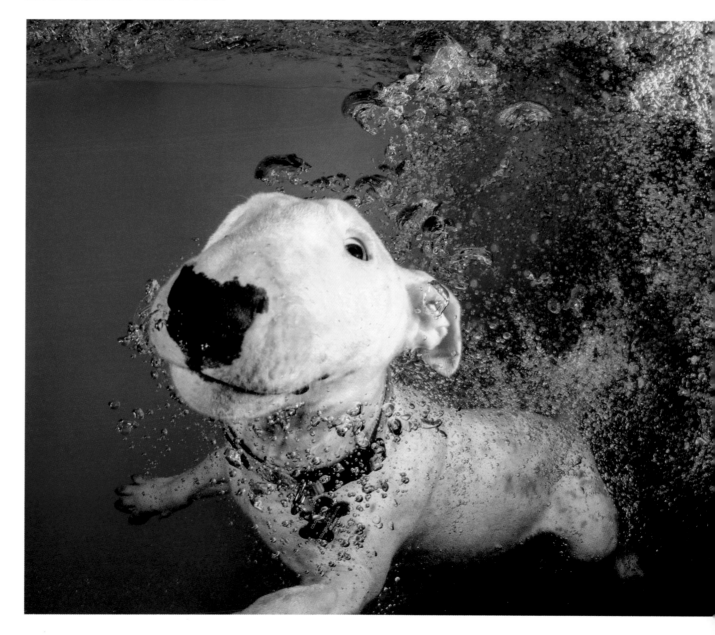

CHARLIE Chocolate Labrador Retriever, 17 weeks

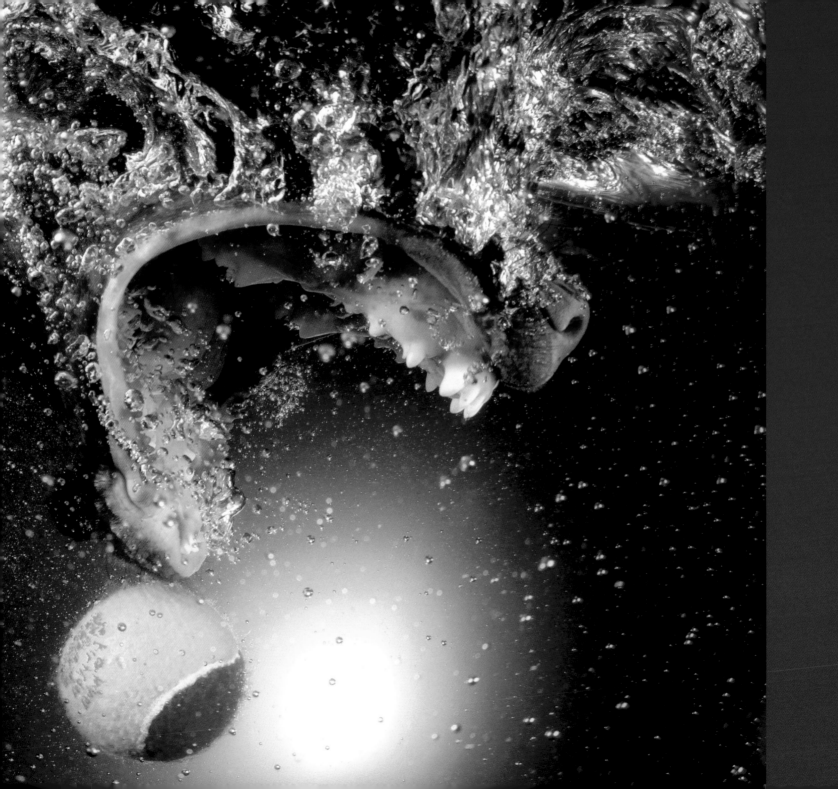

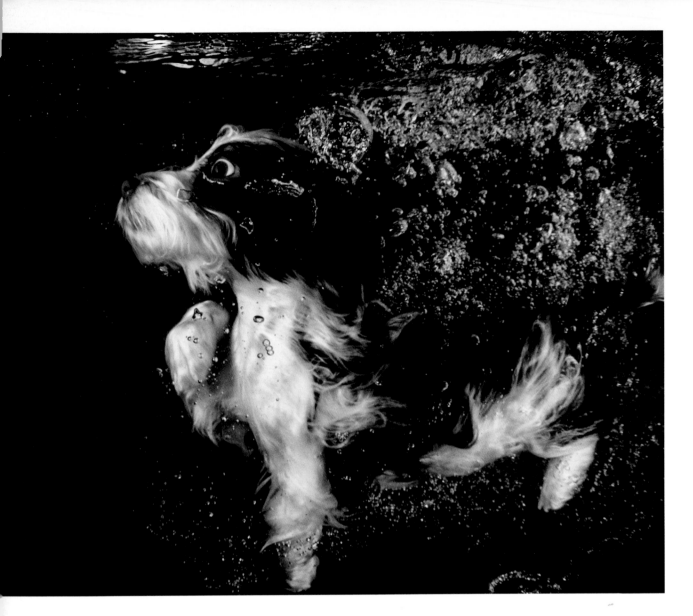

JAX Yorkshire Terrier Mix, 17 weeks

JACK Yellow Labrador Retriever, 12 weeks

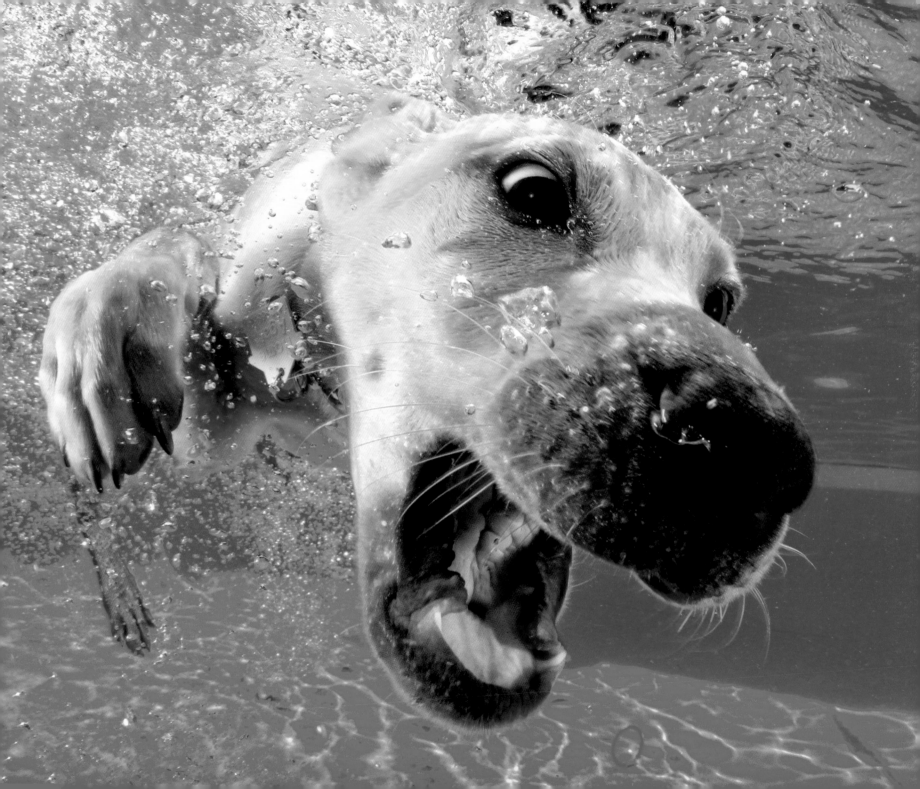

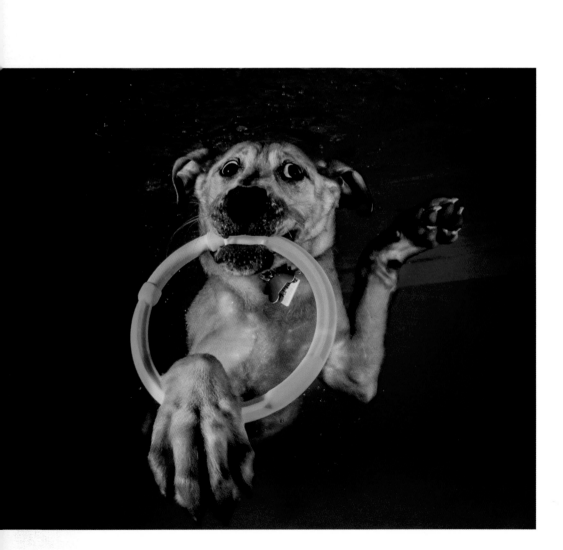

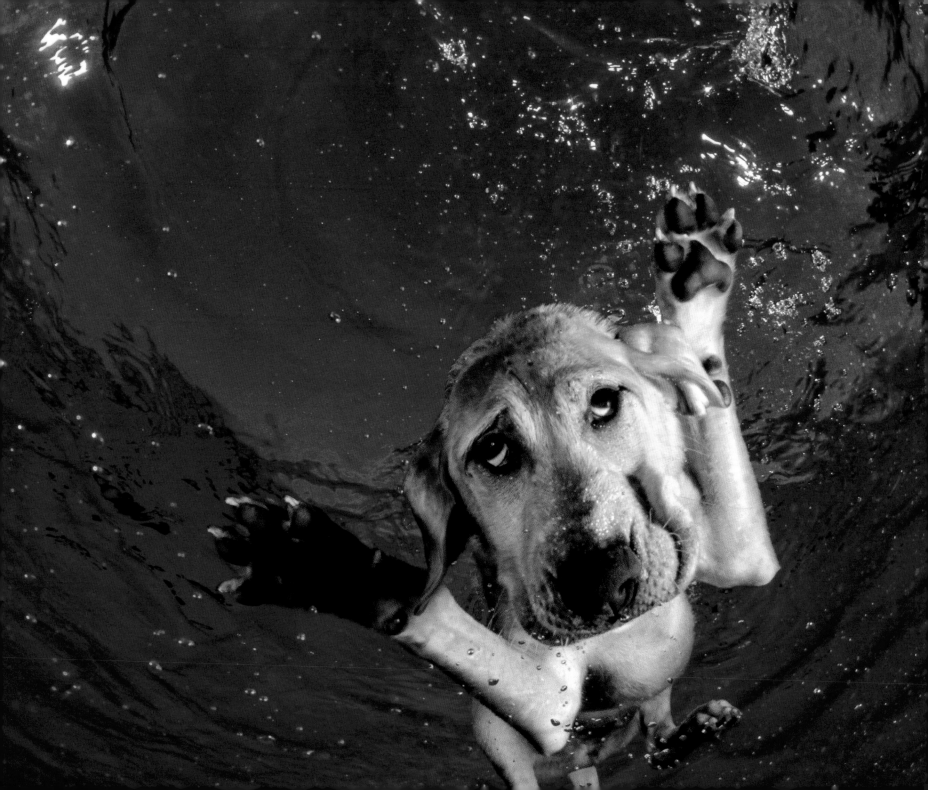

DUNCAN Chocolate Labrador Retriever, 9 weeks

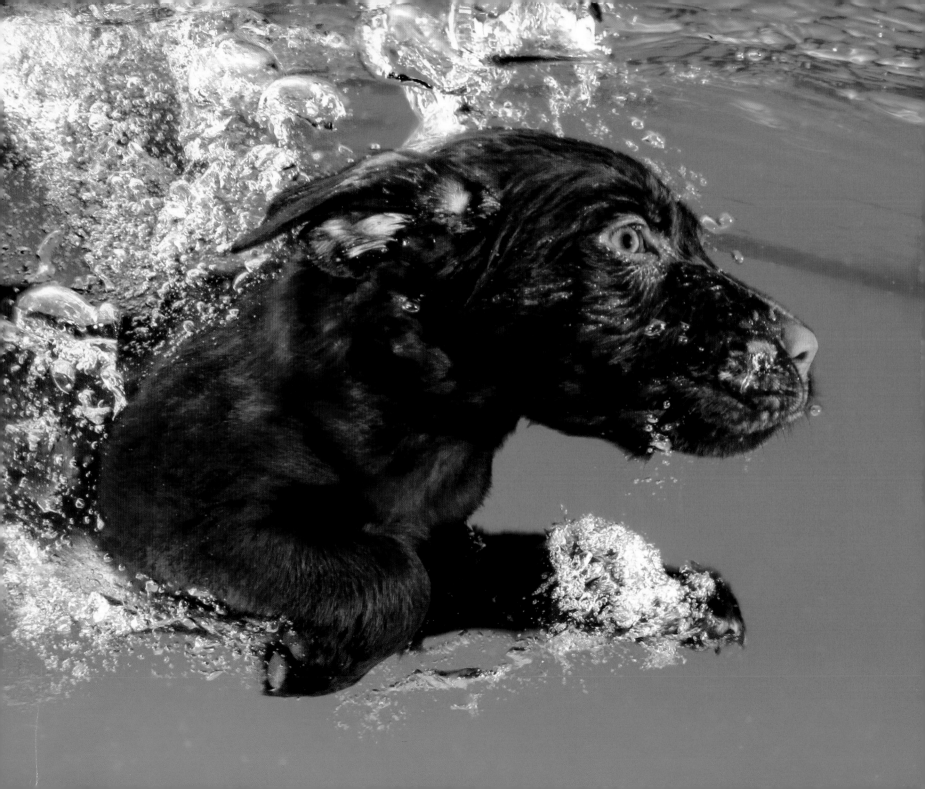

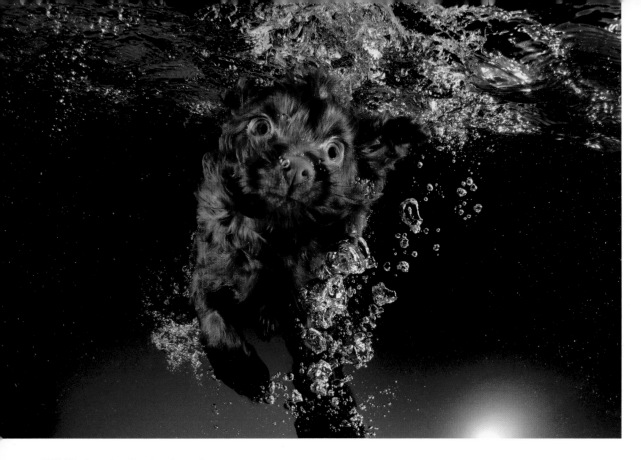

NEVEL Russian Terrier, 8 weeks

IRIS American Pit Bull Terrier, 7 weeks

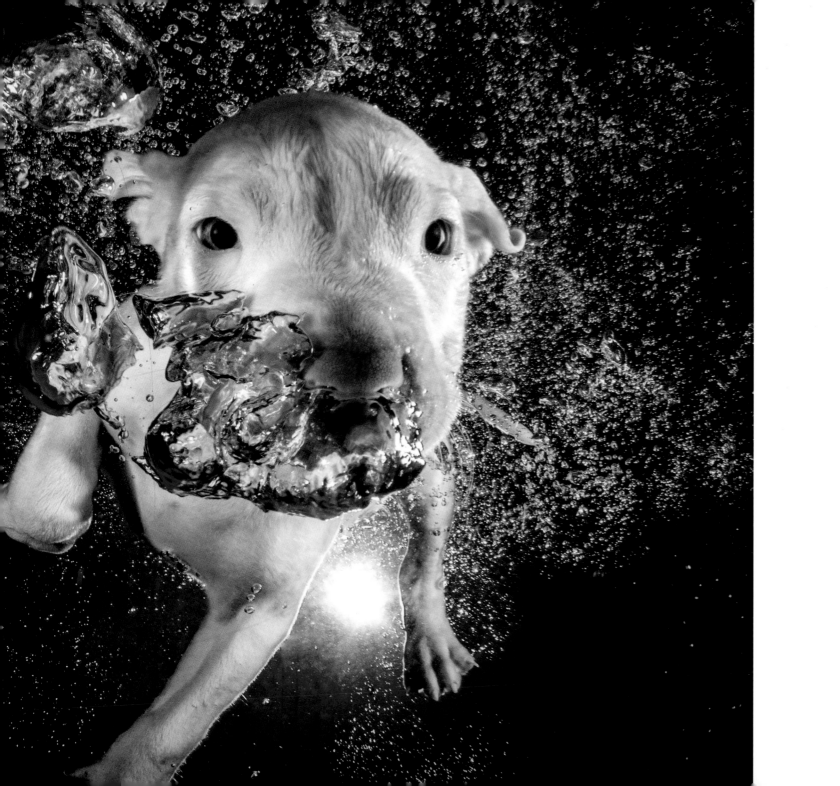

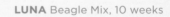

LUNA Beagle Mix, 10 weeks

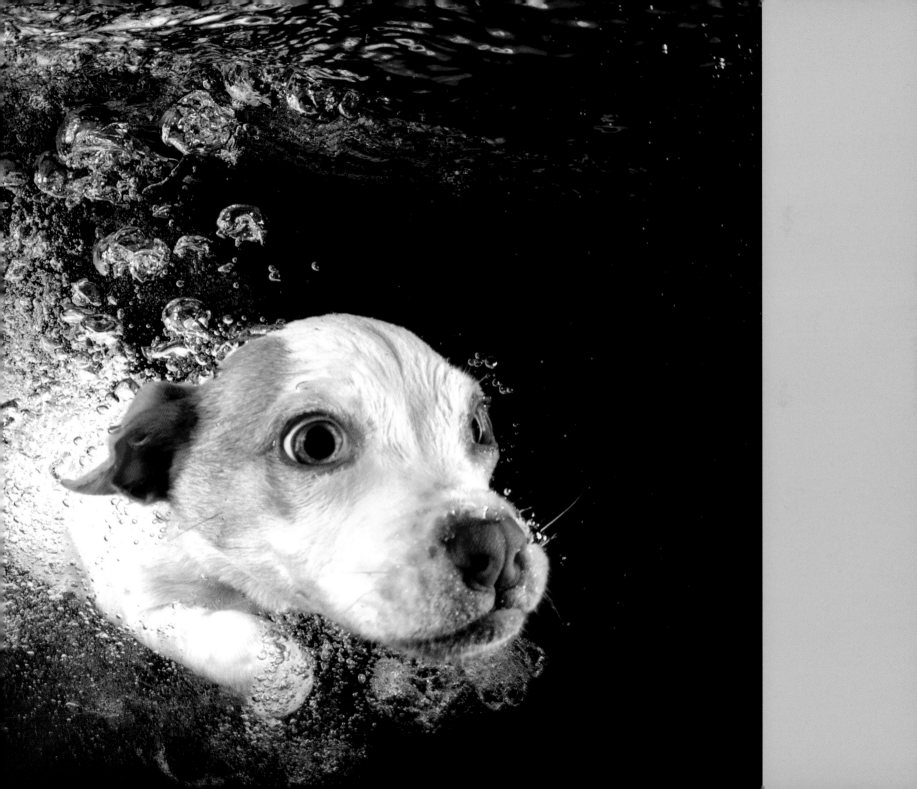

PEPPER Vizsla, 16 weeks

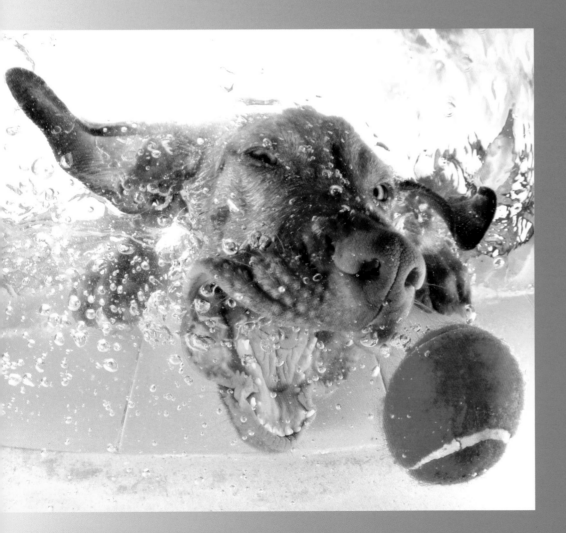

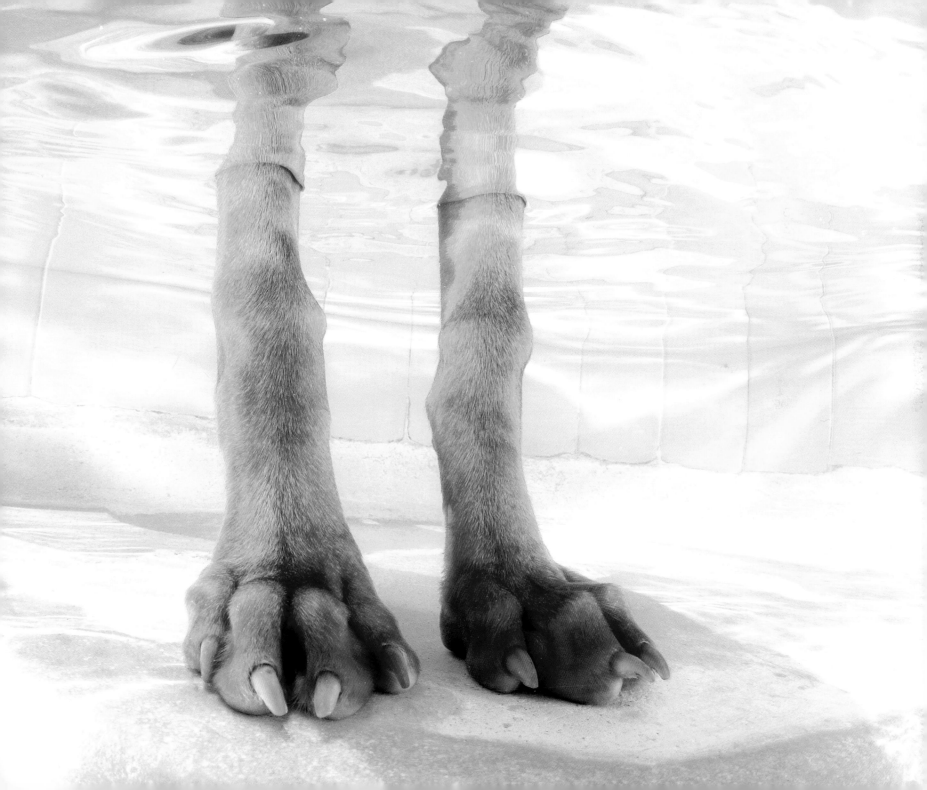

POPSICLE Puggle Mix, 9 weeks

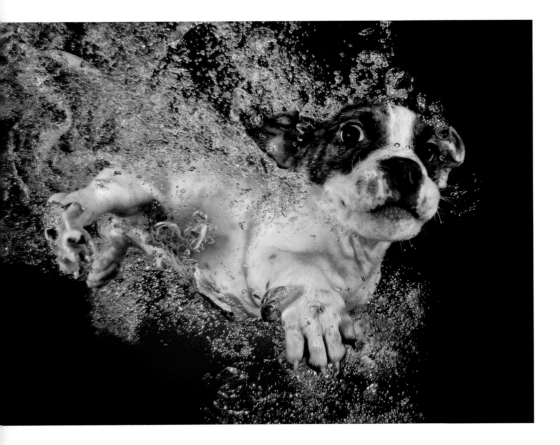

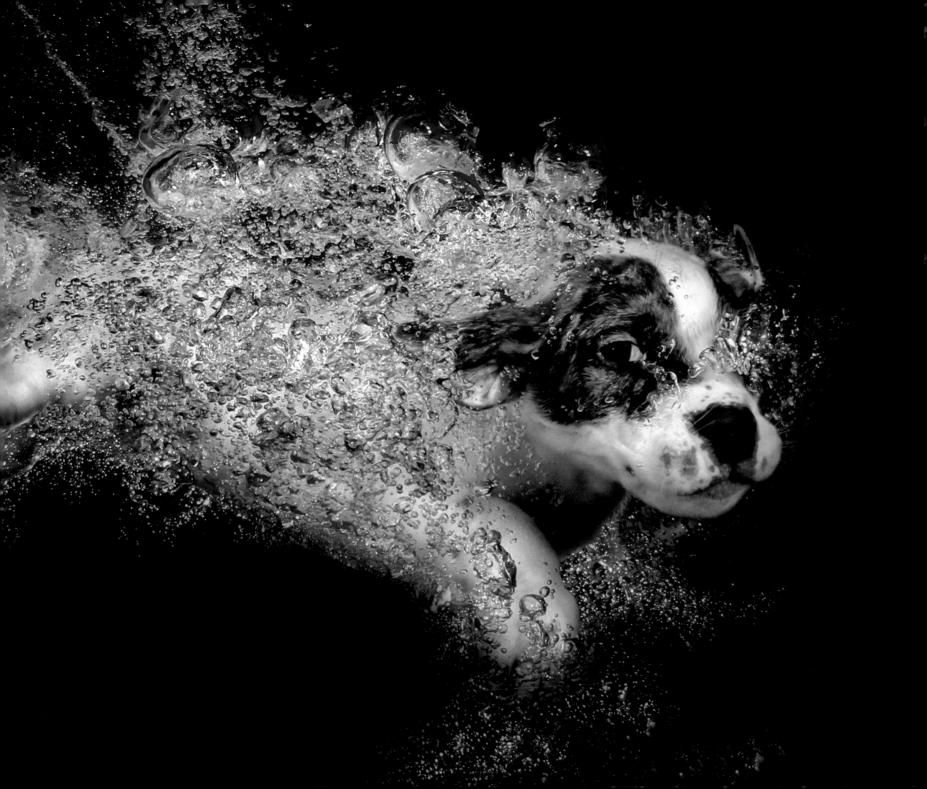

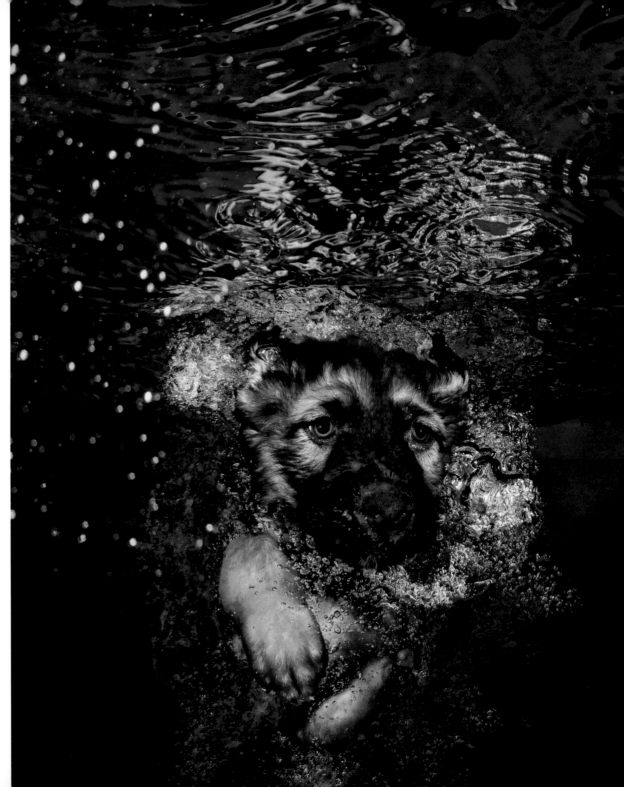

RACHEL German Shepherd Mix, 9 weeks

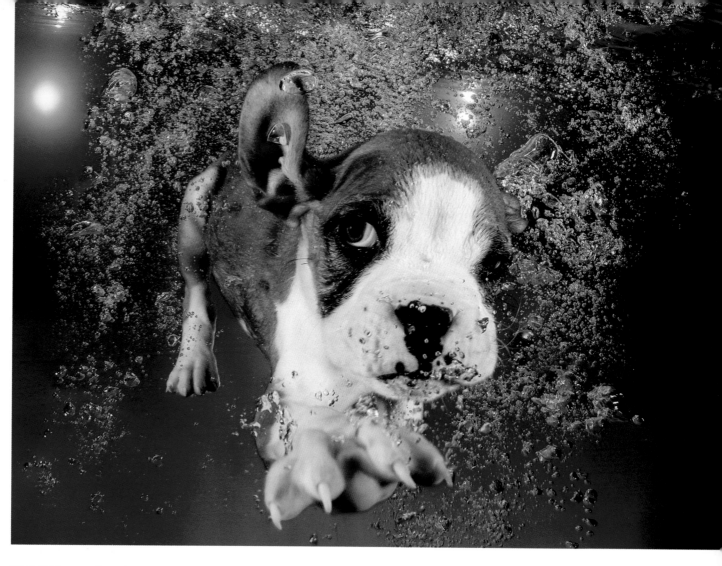

MILLER Boxer, 7 weeks

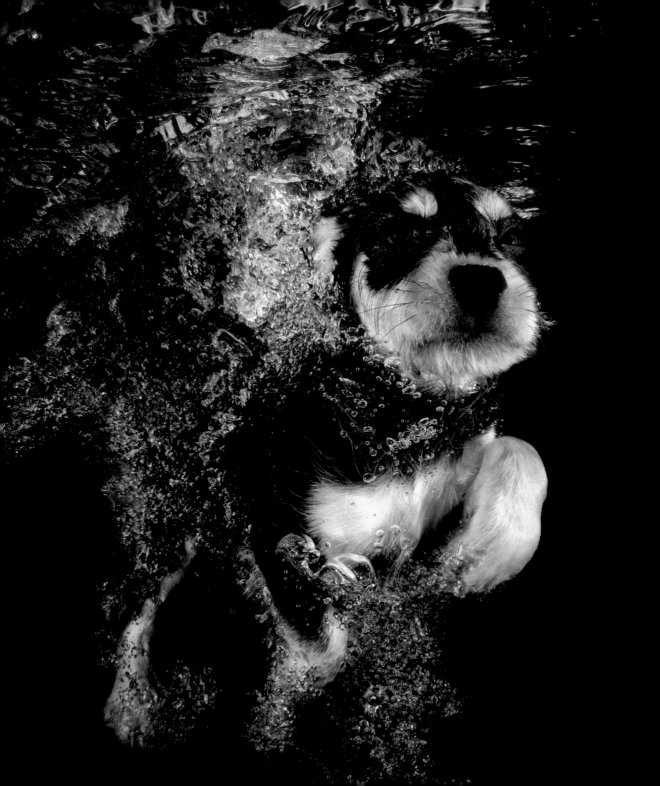

ALEX Terrier Mix, 10 weeks

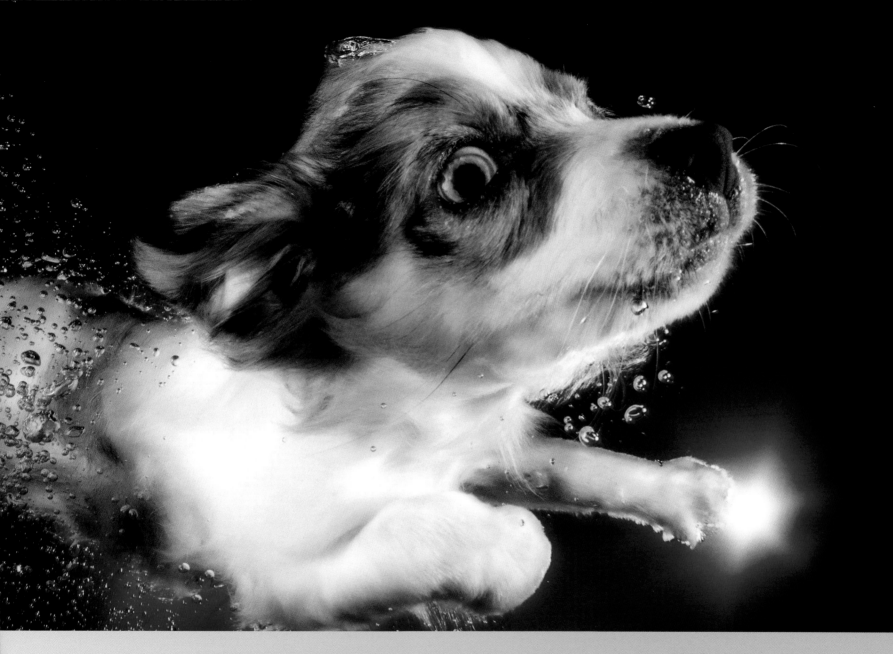

ROO Toy Australian Shepherd, 13 weeks

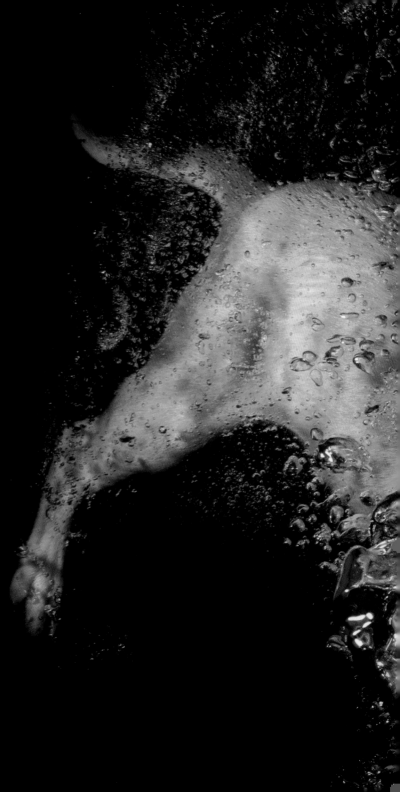

PANCAKE Puggle Mix, 9 weeks

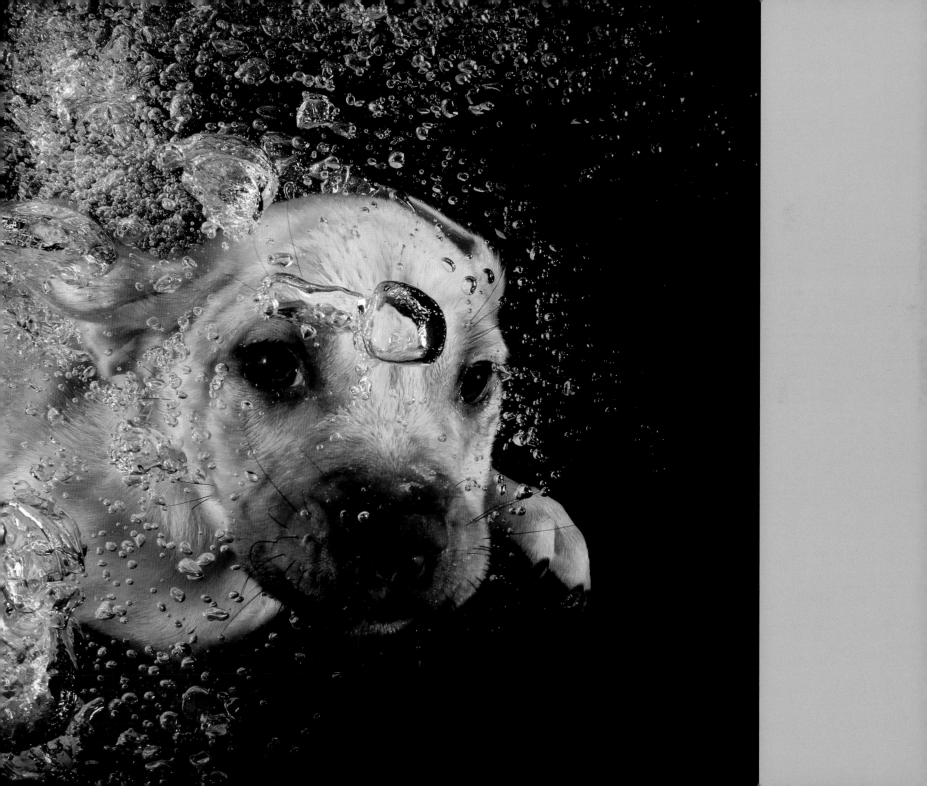

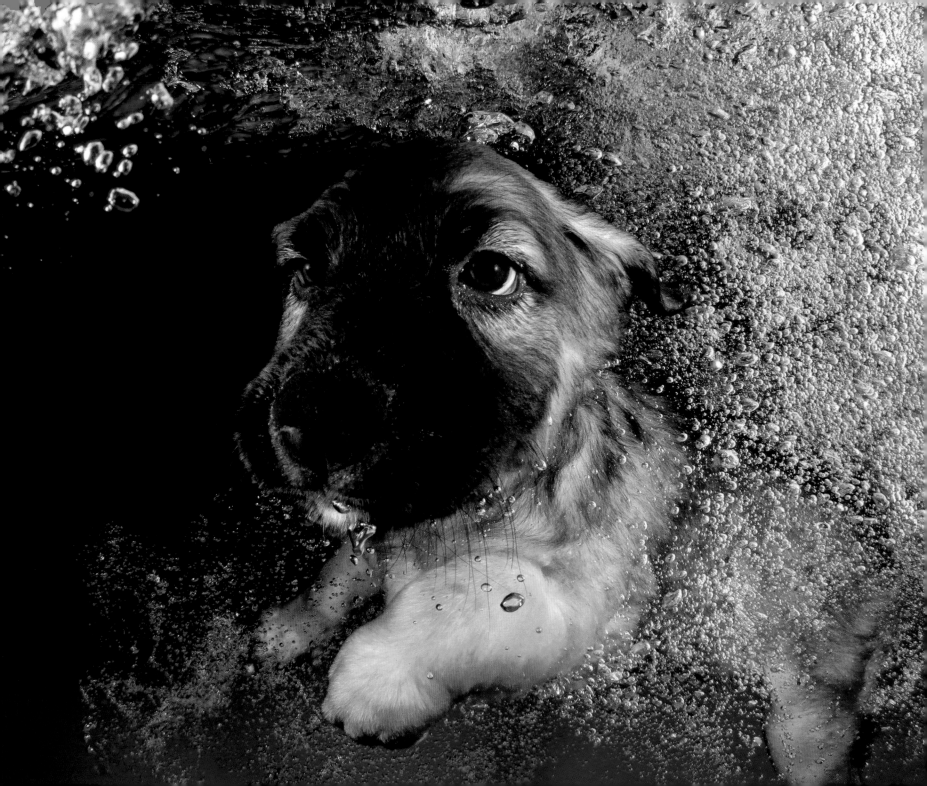

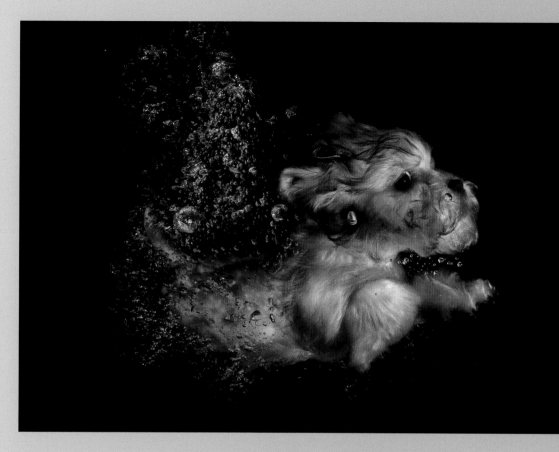

BEAR Shih Tzu/Poodle, 14 weeks

RITZIE German Shepherd Mix, 9 weeks

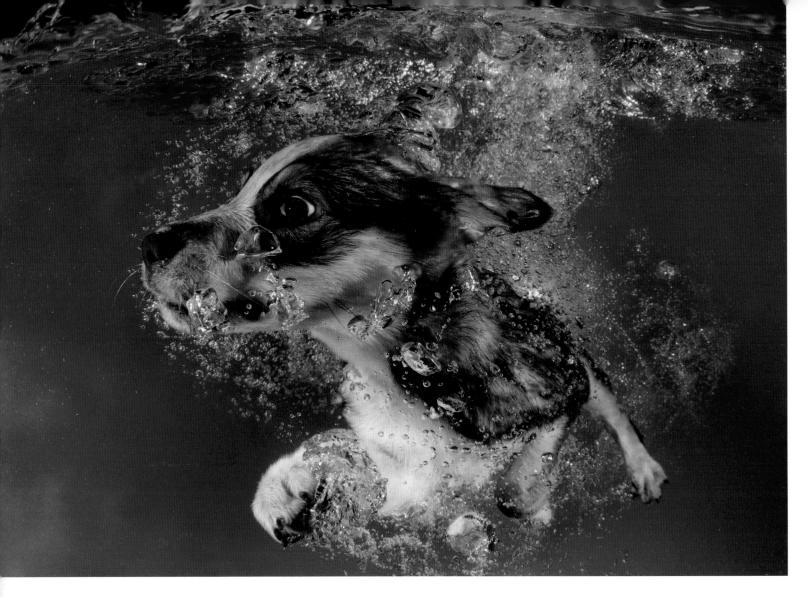

GINGER Border Collie Mix, 12 weeks

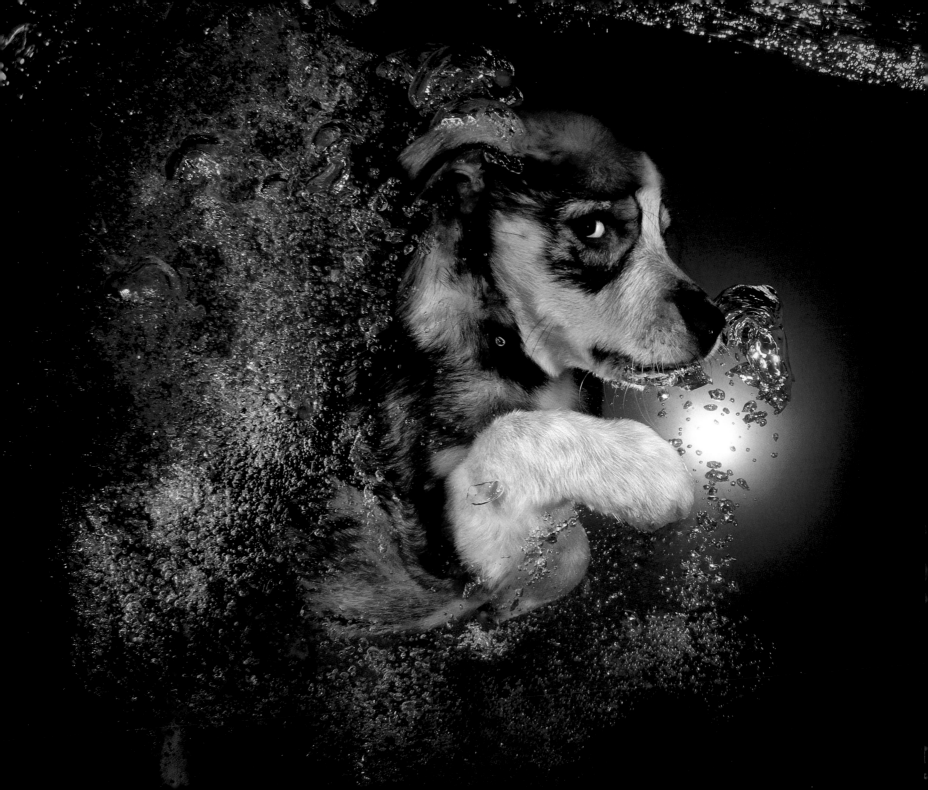

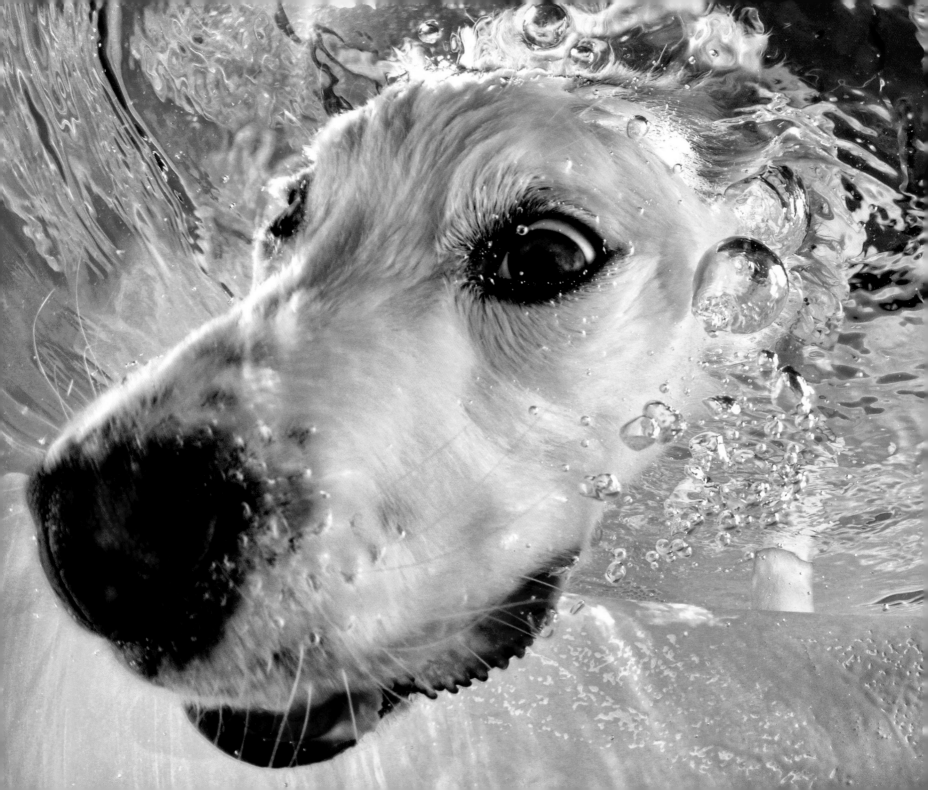

AVI Australian Shepherd/Husky, 5 months

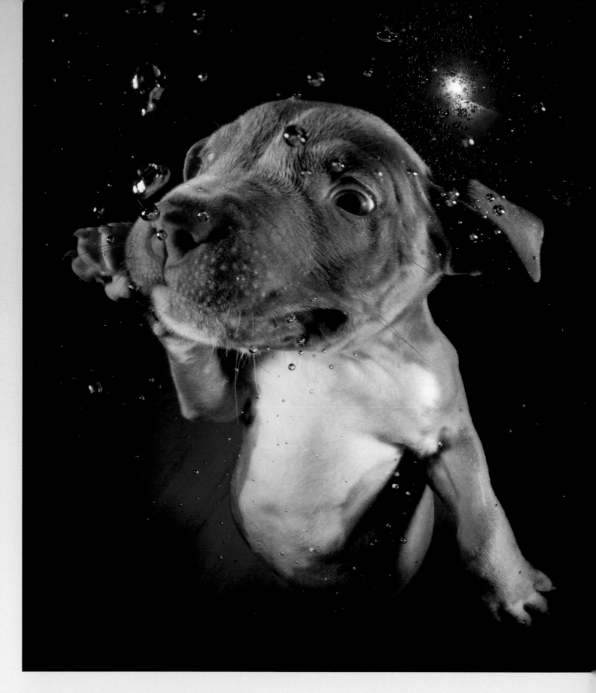

BLAZE American Pit Bull Terrier, 7 weeks

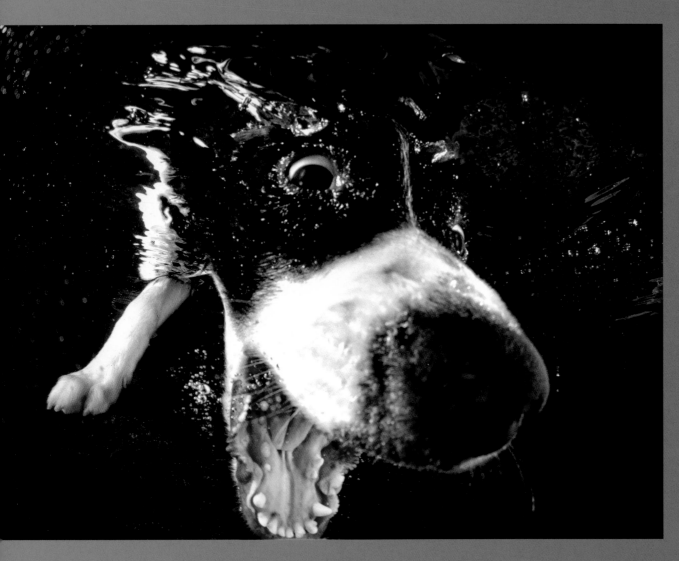

JETT Border Collie, 20 weeks

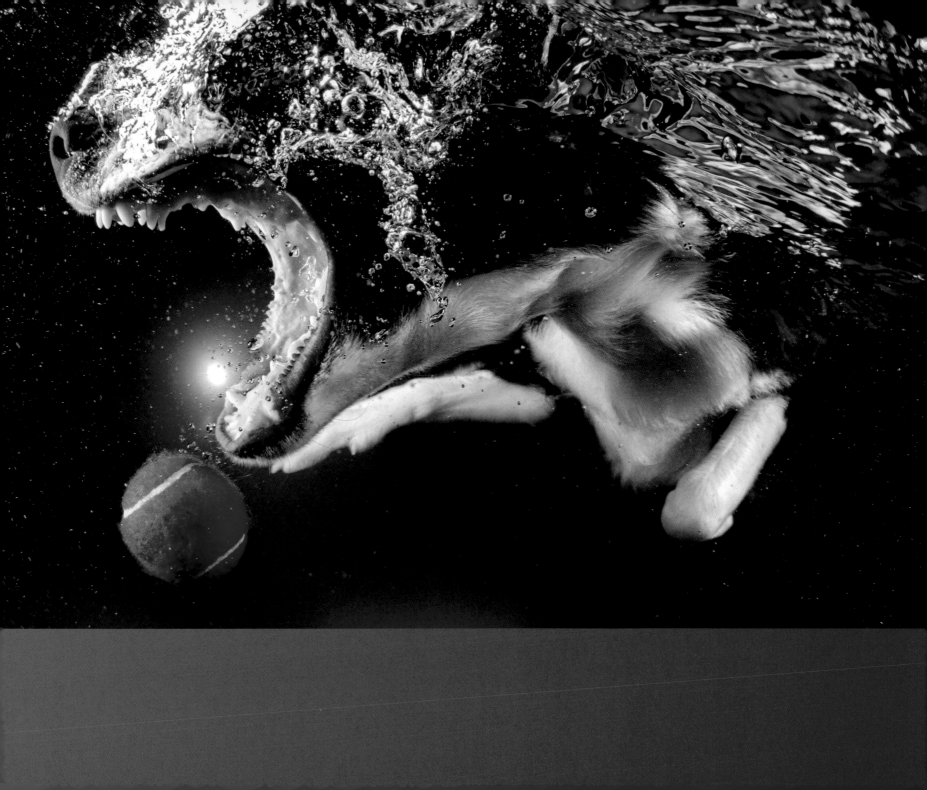

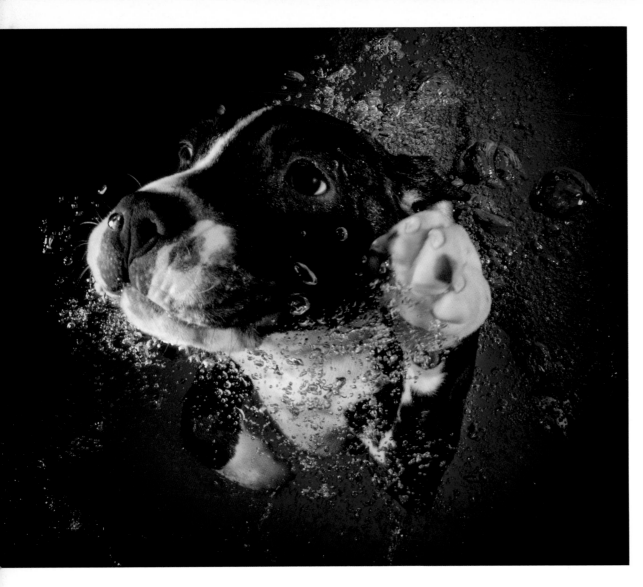

PAUL American Pit Bull Terrier, 16 weeks

GRITS and **REASON** Yellow Labrador Retrievers, 12 weeks

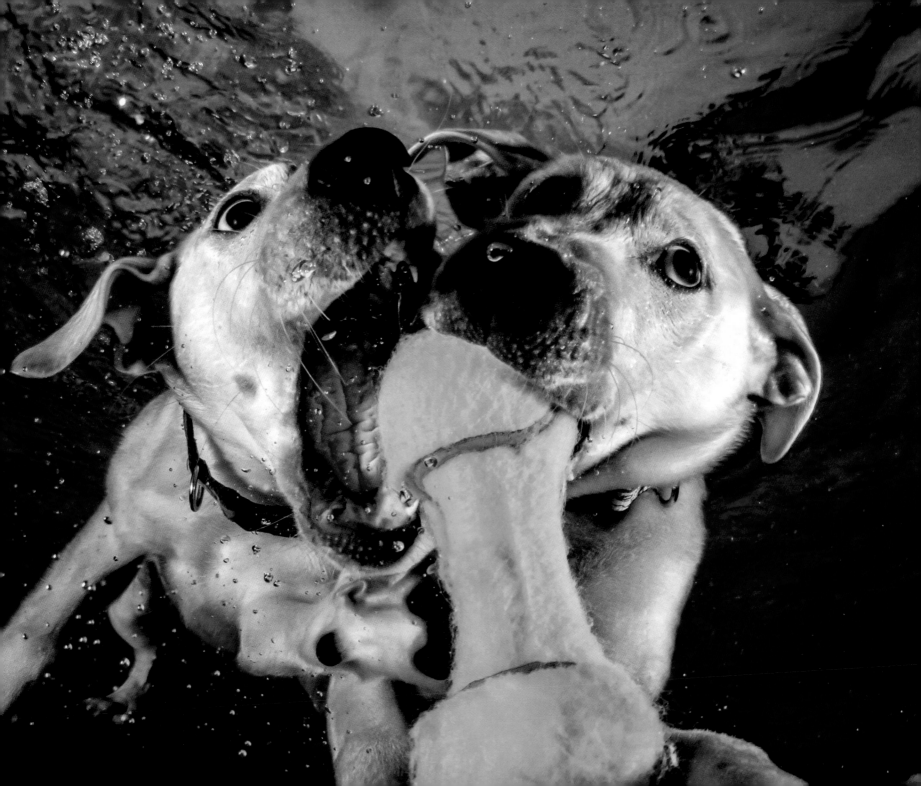

ZELDA Labrador Retriever/Australian Cattle Dog, 8 weeks

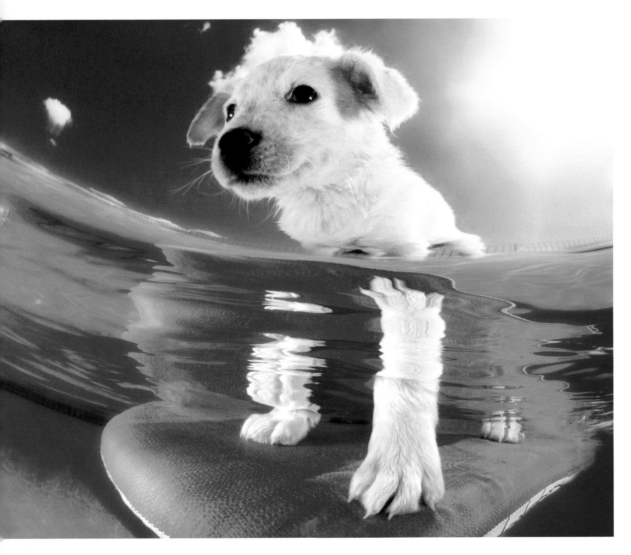

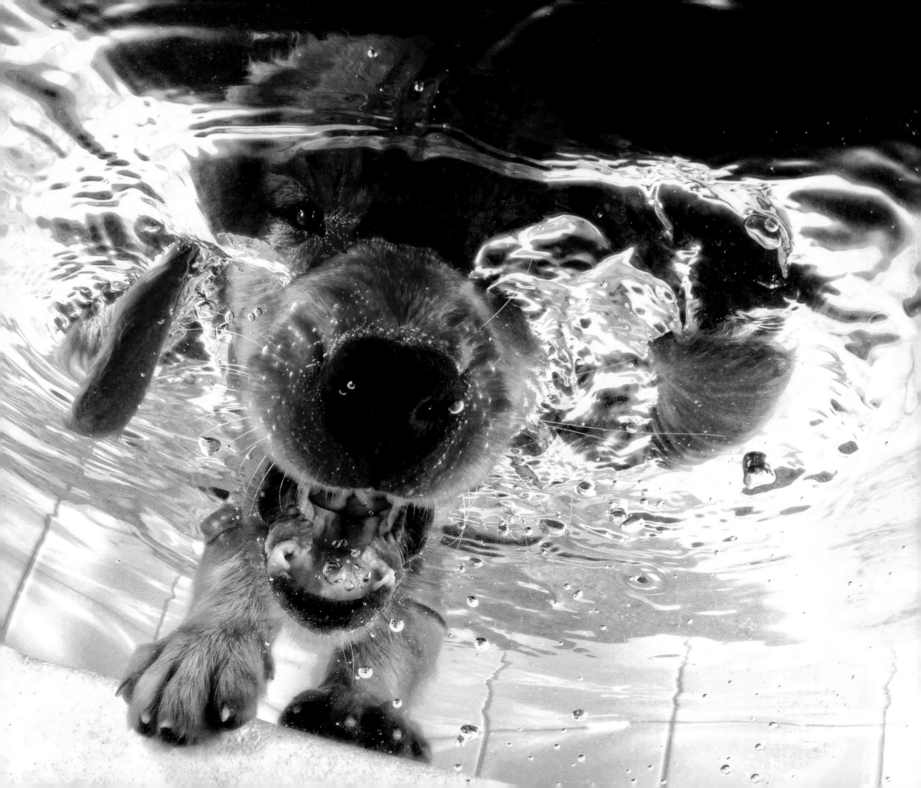

LUNA Border Collie/Labrador Retriever, 18 weeks

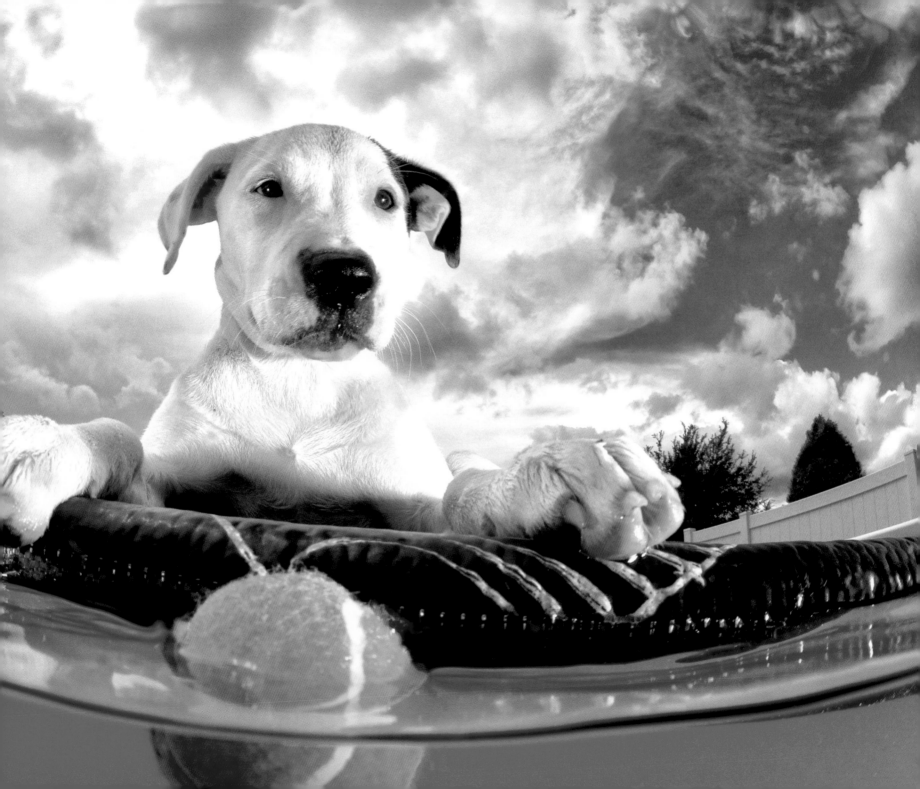

ALEX

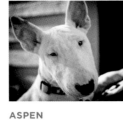

ASPEN

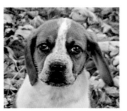

ATTICUS

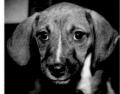

AVA

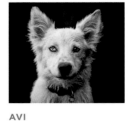

AVI

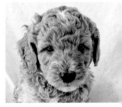

BARCELONA

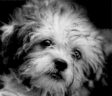

BEAR

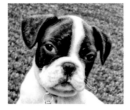

BELLA

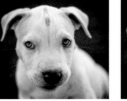

BENTLEY

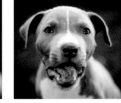

BLANCO

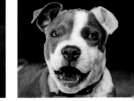

BLAZE

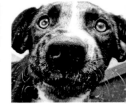

BRANDO

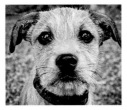

BRUTUS

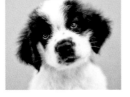

BUTTERBALL

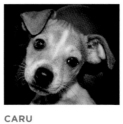

CARU

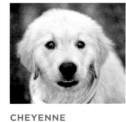

CHARLIE

CHEYENNE

CLYDE

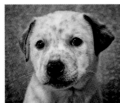

COREY

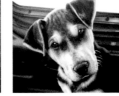

DANTE

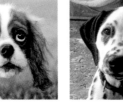

DAPHNE

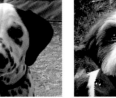

DORA

DOUGLAS

DUNCAN